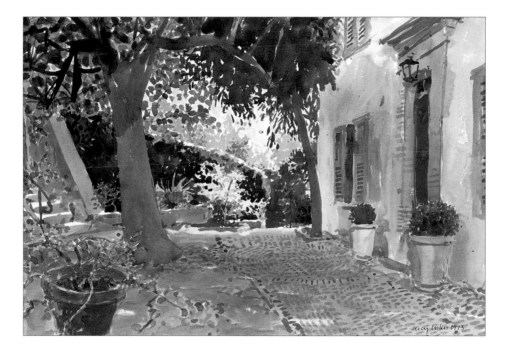

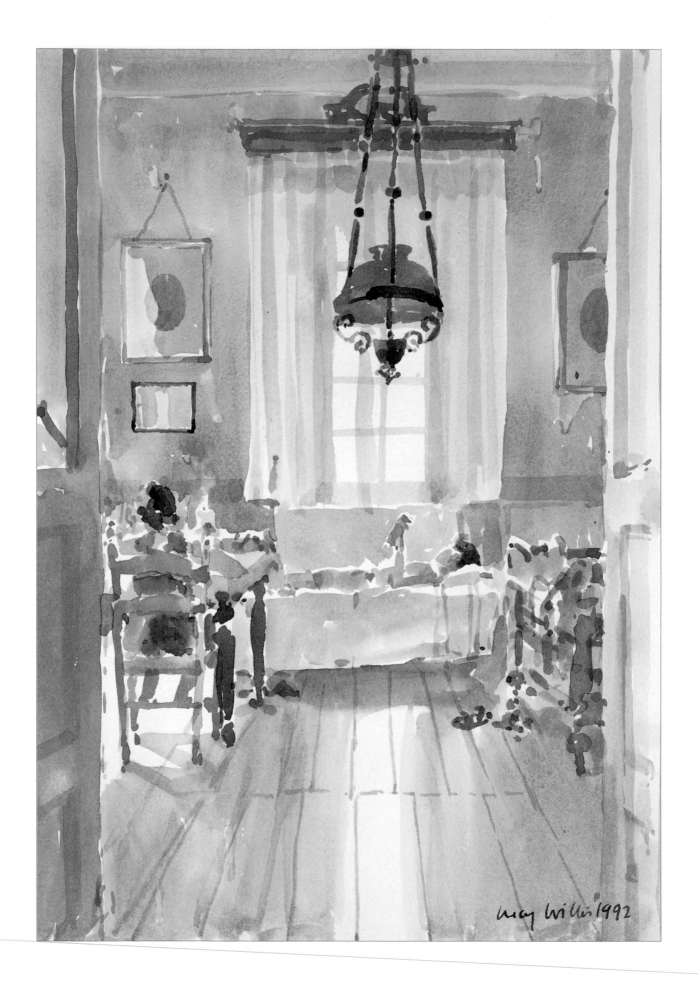

Lucy Willis 1992

LUCY WILLIS
light
in watercolour

Lucy Willis
with
Sally Bulgin

HarperCollins*Publishers*

Dedication

For my mother and father

Acknowledgements

Thank you to Sally Bulgin who had the idea
for this book and whose patience and hard
work made it possible; to Cathy Gosling,
Caroline Churton and Tess Szymanis of
HarperCollins; to Caroline Hill;
to Chris Beetles; and to Tony, Charlie and
Sarah for their help, advice and continued
willingness to model for me.

First published in 1997
by HarperCollins*Publishers*, London

98 00 02 01 99 97
1 3 5 7 9 8 6 4 2

Illustrations © Lucy Willis, 1997
Text © Sally Bulgin, 1997

Lucy Willis hereby asserts the moral right to be identified
as the illustrator of this work.

Sally Bulgin hereby asserts the moral right to be identified
as the text writer of this work.

A catalogue record for this book is available from the
British Library

Text and Consultant Editor: Sally Bulgin
Editor: Tess Szymanis
Designer and Typesetter: Caroline Hill
Photography by Chris Beetles Ltd and Lucy Willis

ISBN 0 00 412976 8
Colour origination by Colourscan, Singapore
Produced by HarperCollins Hong Kong

Page 1:
The Villa Noaille
430 x 635 mm
(17 x 25 in)

Page 2:
The Midday Hour
430 x 320 mm
(17 x 12½ in)

Lucy Willis is
represented by the
Chris Beetles Gallery,
10 Ryder Street,
St James's,
London SW1Y 6QB
Tel: 0171 839 7551.

CONTENTS

PORTRAIT OF LUCY WILLIS

Lucy Willis in her studio.

Greek Pots (1977)
510 × 610 mm
(20 × 24 in)
This early series of watercolour studies (below opposite) by Lucy Willis shows a simple Greek pot under different light conditions.

Lucy Willis was born in Chippenham, Wiltshire, in 1954, and grew up near Wellington in the Somerset countryside.

Her mother and father both studied art at Reading University before following professional art careers and her maternal grandfather, H.M. Bateman, was the well-known cartoonist whose work appeared in *Punch* and *Tatler* during the 1920s and 1930s. Lucy drew and painted regularly as a child and showed a serious interest in art during her teenage years. This interest was developed when she studied at the Ruskin School of Drawing and Fine Art in Oxford from 1972 to 1975, where she followed a rigorous academic training which included drawing from the antique, a study of anatomy and drawing and painting from life. For her final year she also studied printmaking.

After leaving the Ruskin Lucy set up her own etching workshop in Greece and taught drawing and etching to students from the Aegean School of Fine Art (1976-78). She also started to teach herself to paint in watercolours, experimenting with colours from a paintbox given to her by a fellow Ruskin student. To practise handling the medium she made small studies of simple objects at different times of day, combining two of the preoccupations – watercolour technique and her interest in light – for which she has since become recognized as a leading exponent. Her interest in printmaking contributed to the development of her watercolour technique, she believes, as it involved thinking in terms of negative spaces, cutting around positive shapes and separating areas of colour.

When Lucy returned with her husband to Somerset in 1978 to have their first child she began to appreciate the convenience of using watercolour. By developing a style in which speed and concentration were essential she was able to paint in between the demands of looking after a young baby. This also coincided with her developing interest in painting subjects from her immediate environment.

The move in 1979 to an old Georgian farmhouse on the Somerset levels marked a growing commitment to watercolour painting, while the adjoining studio enabled her to teach drawing, painting and printmaking to others. Receiving a travel award in 1981 for a watercolour painting encouraged her to devote

more time to this medium and in 1985 Lucy held her first exhibition entirely of watercolours in Bath, followed by regular watercolour exhibitions at Chris Beetles Ltd in London. This allowed her to give up teaching in 1986 to concentrate on her own work. Other successes followed: in 1992 she won the BP Portrait Award for an oil painting, resulting from her work with inmates at Shepton Mallet Prison, and in 1993 she was elected a member of the Royal West of England Academy.

Invitations to lead painting trips for *The Artist* magazine to Yemen, India, the South of France and Zanzibar helped to widen her subject matter and gave Lucy the opportunity to paint in some exciting and unfamiliar places. Many of the watercolours painted as a result of these trips are reproduced throughout the following pages.

Lucy still lives in Somerset with her husband and two children. Her studio overlooks the garden which provides an endless source of subject matter and inspiration. She now divides her time between painting in watercolour and oils in her own environment, printmaking in her studio, and painting watercolours during her travels abroad.

It gave Lucy much pleasure to share her experiences of painting in watercolour by writing this book. As a student she used to agonize about what to paint and it wasn't until she started to paint in watercolour, that she began to find inspiration simply in the way light affects the subject, no matter what it might be. She also found early on that you must learn to respect and control the qualities of watercolour in order to communicate the impression of light successfully – lessons that she imparts with enthusiasm here.

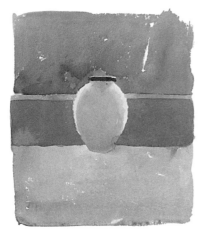

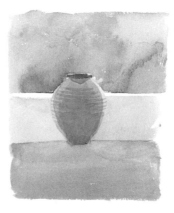

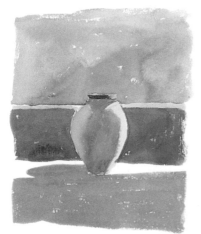

MATERIALS AND EQUIPMENT

Compared with other painting media, it never ceases to amaze me how many watercolour pictures you can paint with the minimum amount of materials. I still find it extraordinary that a tiny blob of watercolour paint can cover such a large surface area, making watercolour the most compact and convenient medium: you can paint anywhere and in any situation with just a sheet of paper, a brush, a basic selection of colours and some water.

Kitchen Window
675 × 510 mm (26½ × 20 in)

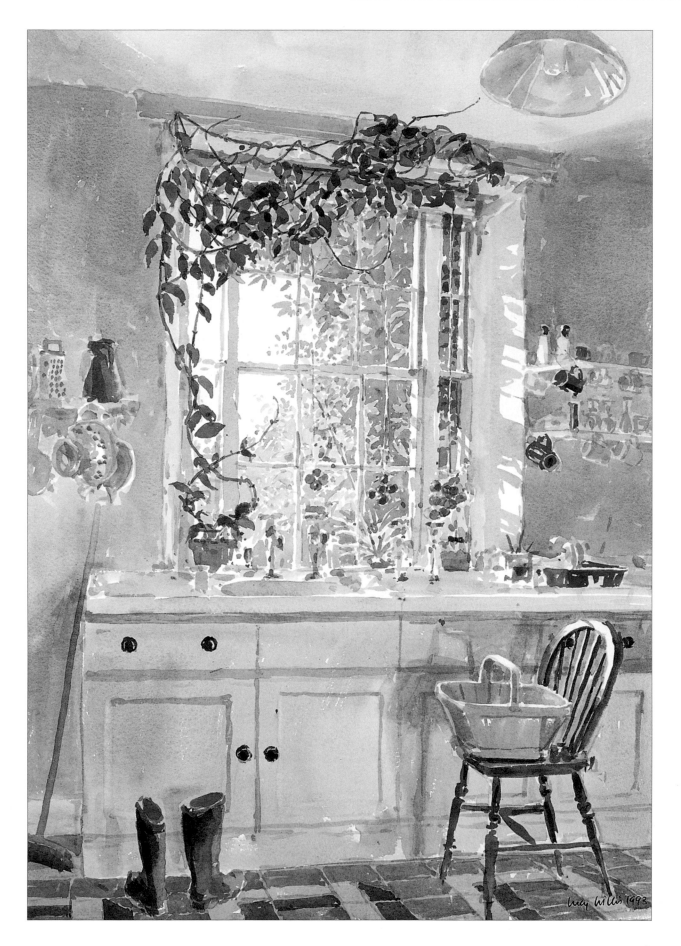

PAINTS

If you intend to take up watercolour painting seriously, you should buy the best art materials available. Although I started with a cheap student paintbox, I remember the thrill of using artists' quality watercolours for the first time and being able to lift the pigment from the pan with ease to achieve a wonderful flood of colour. Lower quality ranges of paints are not only harder work, they may also be less permanent (lightfast) than superior ones.

Artists' quality paints are more expensive than the student quality ranges available, but they are worth it. They contain a high proportion of good-quality permanent pigments. Student quality watercolours contain less pure pigment and more fillers and extenders. The colour is weaker and the selection of colours usually smaller. To begin with you don't need more than a standard box of twelve colours to produce a good painting, and you can achieve much with only six.

Another choice that confronts the newcomer to watercolour painting is which brand to use. The best advice is to try out paints from several manufacturers to find the one that suits you. Remember, too, that you don't need to stick to one brand; good-quality watercolours are compatible across the different ranges. I happily use colours from two or three brands, subject to availability, because I like the qualities of individual colours better in a particular range. Ultimately, it's a matter of personal preference.

PANS AND TUBES

You can buy watercolours in pans, half pans or tubes. I have an enamelled-metal box which contains twelve pans of colour, and a lid that doubles as a palette. It is a good idea to buy the colours you use most (see page 19) in 14 ml (0.47 US fl. oz) tubes, and to refill your pans from these by squeezing out the colours into your pans the night before you need them. By morning, the paint will have formed a skin and can be used in exactly the same way as your other pans of colour. Colours I use rarely are bought in half pans.

At the end of a day's painting, rather than cleaning your palette, you may find that the dried colours are useful for making the preliminary marks at the start of your next painting. They tend to be fairly neutral mixes, or they can be neutralized by the addition of a small touch of another colour.

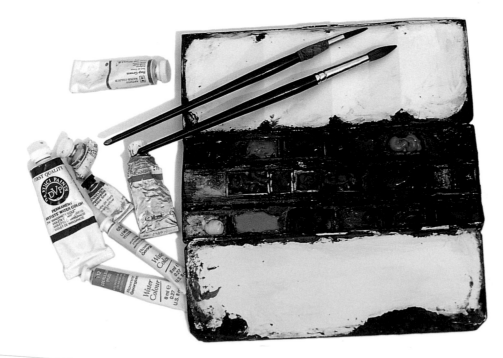

Lucy's enamelled-metal box with tubes.

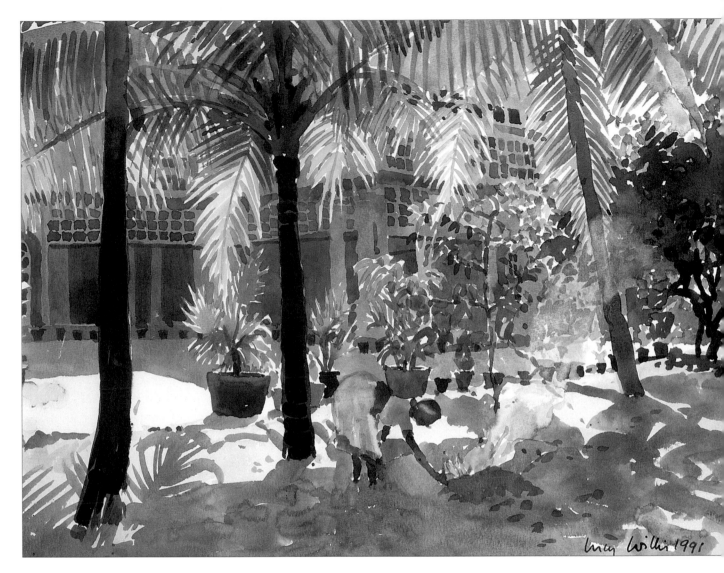

GOUACHE

I occasionally use a touch of designers' gouache, which is available in some very vibrant colours, if I want to achieve the intensity of a particularly bright colour. Because gouache colours contain a high proportion of pigment, their density makes them an opaque paint but they can also be used transparently as ordinary watercolour when diluted.

Some artists use white gouache paint or 'body colour' for adding light tones or specific highlights, but I prefer to preserve the white of the paper for my lightest areas. This requires careful planning at the start of a painting and is fundamental to my watercolour technique (see page 25).

Burning Leaves
320 × 430 mm
(12½ × 17 in)
I used designers' gouache here to achieve the bright pink of the flowers.

11

PAPER

Paper plays an integral role in a watercolour painting. It reflects light back through the transparent colours, contributing to their brilliance, and acts as the lightest tones in a composition when it is left bare. The texture can add enormously to the quality of the wash laid onto it.

A wide choice of different types of paper is available to the watercolourist, which can be confusing at first. It is important to choose the one with which you feel most comfortable. Basically, there are three types: handmade papers, which are the most expensive; mould-made papers, produced on cylinder-mould machines and machine-made papers. The best ones are made from 100 per cent cotton (rag papers) and are tough and long-lasting. All good-quality watercolour paper is acid-free and therefore will not discolour with age as certain cartridge papers will.

PAPER THICKNESS

There are also various weights (thicknesses) of paper, from 150 gsm (72 lb) up to 850 gsm (400 lb). Lighter types of paper (less than 300 gsm/140 lb) may require stretching on a drawing board to avoid buckling and wrinkling when washes are applied. This is important when working on a large scale.

I used to stretch my paper but, for convenience, I now tend to use a heavier 300 gsm (140 lb) paper, unstretched. You can apply washes repeatedly on this weight of paper and it will still stay reasonably flat. Of course, the heavier paper is considerably more expensive and until you are confident with the medium you may want to stick with the lighter papers.

ABSORBENCY AND SIZING

The absorbency of a paper depends on the degree to which it is internally or surface sized. This is the manufacturing process during which the size (gelatin) is either added

Nude Study
255 × 180 mm
(10 × 7 in)
Not surface watercolour paper is very versatile. You can apply smooth, even washes or vary the texture by using the dry-brush technique in which the pigment particles catch on the tooth of the paper, missing the hollows and leaving dots of white to sparkle through the wash. First flick your brush to remove excess water before lightly sweeping it across the dry paper.

▶ *Tuscan Courtyard*
320 × 430 mm
(12½ × 17 in)
The white of the paper plays a fundamental role in a watercolour painting. Here, to suggest the effect of the light illuminating the background wall, the paper was left bare for the lightest tones, with just a tint of different beiges in places to suggest the stonework.

to the paper pulp (internal sizing) or applied to the surface of the finished paper (surface sizing). Bockingford paper, which I use frequently, is internally sized and has a robust, non-absorbent surface; the colours remain brilliant on this surface because they do not sink into the paper. It is easy to lift colour off, even when dry, and it leaves very little stain on the paper (see page 30). This can be a great help when making alterations or correcting mistakes. On lightly sized papers, on the other hand, the colours sink in and dry more quickly and you don't get such granulation of colours because they don't have time to settle on the surface and precipitate.

SURFACE TEXTURE

There are three choices of surface texture for watercolour paper: hot-pressed or HP (smooth, ideal for precise, detailed work); cold-pressed or Not (a medium, semi-rough surface) and Rough (a more pronounced texture). I prefer the medium texture Not surface as it responds well to washes and the grain picks up the granulation of some colours, contributing a liveliness to flat areas of colour.

SHEETS, BLOCKS AND PADS

I generally buy large quantities of single sheets of watercolour paper, 560 × 760 mm (22 × 30 in) or 635 × 430 mm (25 × 17 in), which I use whole or cut into different, smaller sized sheets to carry in my portfolio for outdoor work. Watercolour blocks, available in a range of sizes, are equally convenient; the backing board makes a good support and as the watercolour paper is glued around the edges there is no need for stretching. Watercolour boards (watercolour paper mounted onto a strong backing board) also avoid the need for stretching single sheets of paper.

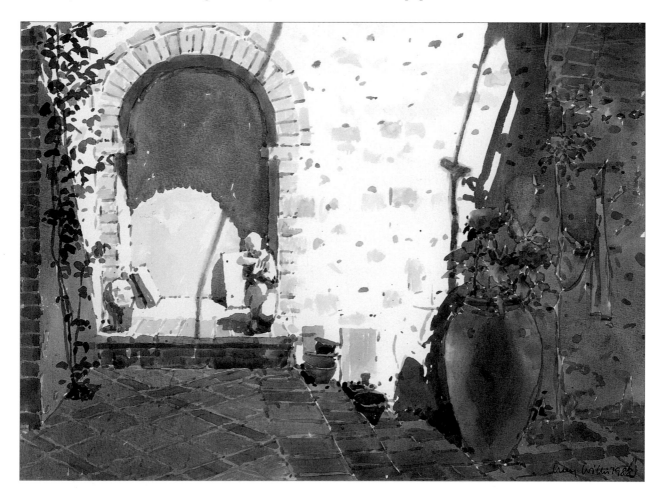

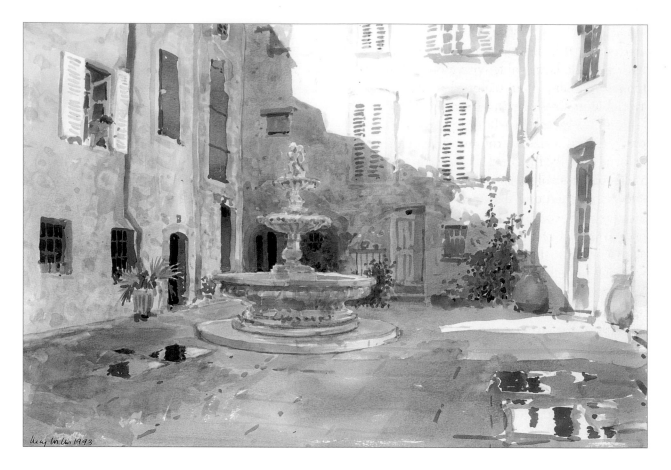

BRUSHES

Watercolour can be applied to paper successfully with almost any type of brush. However, a split point or a brush that is too small can be extremely irritating, so I believe that it is false economy to buy cheaper brushes. Buy the best you can afford – one that has a good 'belly' which will hold plenty of colour, and which when fully loaded with water returns to its original shape. Sable is the best; the hair is strong yet springy, and it holds its shape well. Other animal-hair brushes (squirrel, ox, goat) can be used; I started with an oriental calligraphy brush but now I much prefer using a good sable. I avoid using synthetic-hair brushes as I find that they do not readily release water. The fact that sable brushes release water with one flick of the wrist between applications of colour makes them ideal for controlling the quantity of paint; with several flicks they are dry enough for mopping up excess water from washes.

After Rain, Tourrette
430 × 635 mm
(17 × 25 in)
The large wash of the shadows and the finer details in this painting were all achieved with a fairly large brush with a good, but not too sharp, point.

▶ *Tuscan Hillside*
205 × 255 mm
(8 × 10 in)
I carry a selection of different-sized papers in my portfolio so that I can suit the size to the subject and time available. This small landscape was sketched during a brief stop whilst travelling around Italy.

Different shapes of brush suit different artists. But it is amazing what you can achieve with a single large sable with a good, but not too sharp, point. Watercolour brushes are available in sizes starting from 00000 to large No. 24 wash brushes; my personal preference is a size 14 round brush. This can be used equally for finer strokes, flat washes and broader strokes, so in fact you don't really need more than one size of brush; although I usually use two. Like many artists I enjoy the blunted effect of a slightly worn brush, after about two month's heavy use; sometimes, I snip off the very pointed ends of brand new ones. After a couple of years these brushes become too blunt for fine work but they are still useful for larger washes.

OUTDOOR EQUIPMENT

For outdoor work I keep my equipment simple. I generally work sitting down on a low plastic folding stool and, rather than using an easel, I support my portfolio on my knees and use it as a board for resting my paper on. It is important not to sit on too high a chair (my stool is about twelve inches tall), because your paper will slope away from you, not only causing your paint to run, but also playing havoc with your drawing and perspective, leaving you with a distorted view of your picture. It is best if you can get an almost perpendicular view of your paper.

As well as the stool I take a blow-up cushion for comfort, and a Chinese-style folding hat to keep the sun out of my eyes and, if the sun is behind me, to shade my paper from its glare.

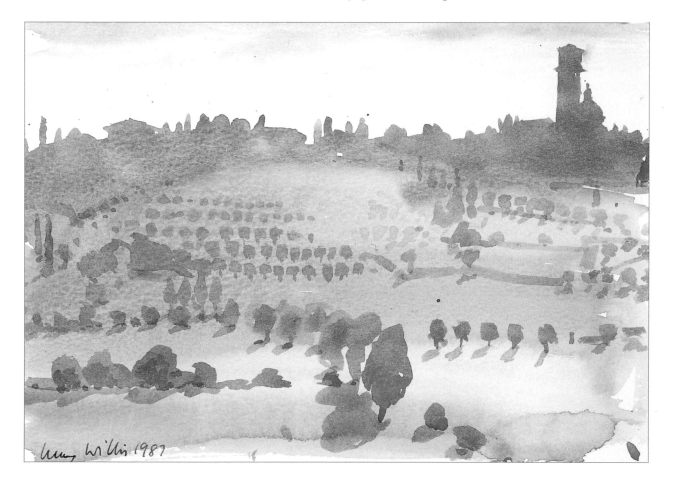

WORKING WITH WATERCOLOUR

Watercolour is a wonderfully translucent medium and ideal for capturing the effects of light. But because of its fluid nature it can also be difficult for inexperienced painters to handle effectively. Nevertheless, with an understanding of how the medium behaves, and regular practice, the difficulties of watercolour painting are amply compensated for by the range of expressive, and sometimes delightfully unpredictable, effects it can create.

To begin with it may seem like a precarious juggling act. You need to be able to control when and how colours run together and when and how they must be kept apart; your paint must not be too wet, and yet not too dry, and the white of your paper should be seen as much an integral part of your palette as red, yellow or blue. Watercolour can be crisp, sharp and fresh, or soft, blurred and subtle, all in one painting. Learning the different techniques is undoubtedly challenging at first but once you get the hang of the medium the possibilities are endless.

Gate at the Top of the Steps
430 × 320 mm (17 × 12½ in)

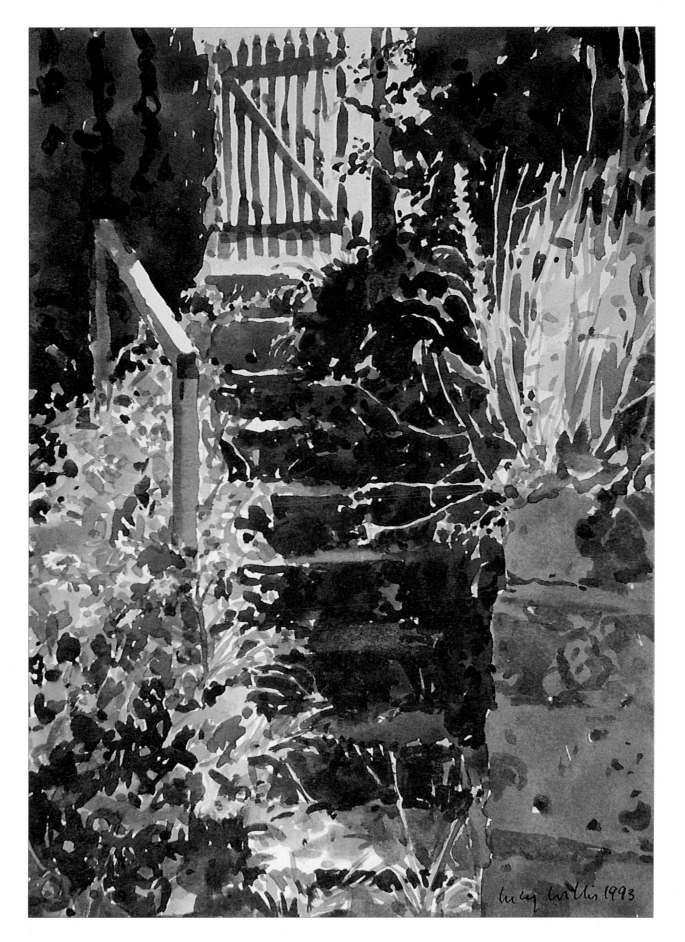

COLOUR

Understanding the basic principles of colour and colour mixing is fundamental to the successful use of watercolour, although you need not be inhibited by rules. More importantly you must develop the confidence to rely on your observation of the subject, to recognize warm and cool colours, and to relate the colours in your palette to those in your subject matter.

PIGMENTS

Transparency is the quality most associated with watercolour painting, yet pigments can be categorized into three main groups: transparent, opaque and staining colours. Some colours are more intense and have greater tinting strength than others. Additionally, some transparent colours, such as Viridian, which I rarely use, are also staining colours.

You need only worry about staining pigments, however, if you make mistakes and want to lift colours out completely and return to white paper. I suggest that you avoid lifting out colours to begin with, especially when making practice paintings. It is far better to discard unsuccessful studies as soon as they begin to go wrong than to try and redeem them by over-manipulating the paint.

WARM AND COOL COLOURS

When learning to see colours, their relative warmth and coolness is possibly the most helpful characteristic to look for. Warm colours consist of yellows, reds and oranges; cool colours include the greens, blues and purples. Within this generalization, however, each colour also has its own degree of warmth and coolness. For example, Cadmium Yellow is a warm yellow, while Lemon Yellow is cool. Look for these qualities; if the surface of an object changes direction, can you see a change in the warmth of its colour? And how does this compare with the warmth or coolness of whatever the object is next to? Notice, too, how the prevailing light also determines the warmth of a colour. Neutral colours, like greys and browns, also have endless varieties of warmth or coolness and in watercolour the temperature of a colour can be gently varied within a single wash.

When learning to see warm and cool colours, painting a white still life can be one

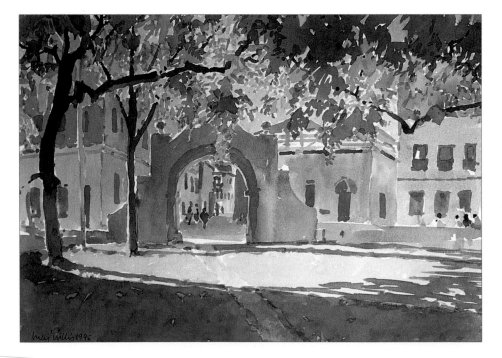

Cemetery Archway
320 × 430 mm
(12½ × 17 in)
Look for the relative warmth and coolness of colours. Note here how the green is affected by the evening light, making it warm and yellowy in the sunlight and a cool blue-green in the shadows.

◀ The first few washes established the position, shape and colour of the main objects. I used a basic mixture of Cerulean Blue and Winsor Violet, to which I added Yellow Ochre to describe the reflection of the warm light in the shadows.

◀ *Studio Study*
305 × 380 mm
(12 × 15 in)
Next, I painted the shadows of the objects using the same mixture, darkening some of the darks with a second wash and muting some of the brighter colours of the first few washes.

Finally, I deepened some of the tones, reinforcing the coolness in some areas, and clarified the edges of certain shapes.

of the most helpful exercises you can do. You will probably be surprised to discover an extensive range of colours within the warm and cool greys.

Any arrangement of white objects will do: cups and saucers, milk bottles, etc., are all ideal. For the study, shown above, I chose a selection of white oddments from my studio and set these on a sheet of white paper on a table under a window with the light striking the objects from behind.

When you set up your own still life, notice the range of yellow-greys, blue-greys and the darkness of the tones in the shadow areas. Look for where the colour changes from warm to cool; scrutinize the subtle changes of colour.

You should choose three basic colours. For the study shown above I used Cerulean Blue

for my cool colour, Yellow Ochre for my warm, plus Winsor Violet, which is halfway between the two.

A RECOMMENDED PALETTE

A palette of eight basic colours – two of each of the three primaries supplemented with a green and purple – is a good idea for inexperienced painters to start with. You should be able to mix everything you need from these.

For my primaries I like to use: Cadmium Yellow and Cadmium Lemon Yellow; Cadmium Red and Alizarin Crimson; Cobalt Blue and Cerulean Blue. I supplement these with other favourites, which include: Yellow Ochre; Cadmium Yellow Deep; Sap Green

(a transparent green which is a useful mixing colour and good for foliage colours); Winsor Violet (useful with Cerulean for mixing greys and shadow colours – I rarely use it on its own); Ultramarine and Prussian Blue (good mixing colours for very dark darks, although beware of the strong staining quality of Prussian Blue) and Ivory Black.

I suggest that inexperienced painters avoid using black to begin with; the temptation to use it to darken shadow colours should be resisted as it can deaden your colours.

I don't carry Chinese White, or any sort of opaque body colour, with me when I am working outside, but I do keep some in the studio for making corrections (see page 31). I prefer to leave the white paper for my lightest tones, if I can.

MIXING COLOURS

In watercolour painting there are three basic ways of mixing colours: on your palette; on your paper, by overlaying a wet colour over the top of one that has dried thoroughly; allowing two or three wet colours to mingle into each other on your paper. I use all three techniques in each painting to a greater or lesser degree, depending on the subject.

My basic technique involves mixing the right colour on the palette first and applying it to the dry paper in the required shape. Remember that your colours will become dead and muddy if you try and manipulate the paint too much once it is on your paper. Try out your colour on a separate sheet of paper first, if you are unsure – my 'try-outs' are done on the painting itself: I mix my colour, apply a dot of it to the painting and if it's too light, too dark, or the wrong colour, I quickly adjust the mixture before continuing.

Clean colours
Essentially, clean, bright colour depends on the handling of the paint and the application of the washes. I find it helps to think of each shape you apply to a painting as a wash in itself, applied by the technique described earlier of putting on the pigment and leaving it to dry. The quality of the edges of shapes is also of paramount importance; the crispness and freshness of a watercolour can be lost if edges are scrubbed and blurred by too much fiddling.

Colours and tones are influenced by those around them in a painting, so the impression of vibrant colour depends on what colours you put next to each other – bright colours seem richer next to neutral ones and dark tones

Concarneau Street Scene (detail)
320 × 430 mm
(12½ × 17 in)
I first laid a blue-grey wash over the facades of all the buildings in shadow. When this was completely dry, I painted on the window surrounds and other architectural details with a mixture of Yellow Ochre and Cadmium Red, through which the blue-grey shows, resulting in the desired colour and tone.

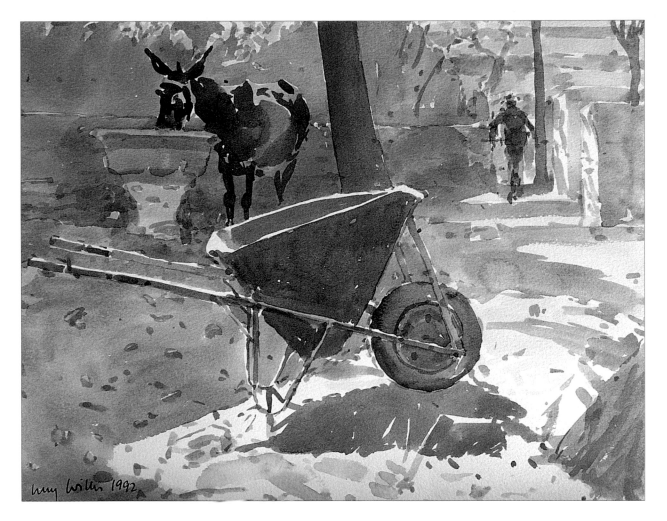

intensify next to light ones. Even with neutral or muted earth colours, if the tones are right, and they are in the right place, they will look fresh.

Colourful greys
Mixing complementary colours together produces rich, neutral greys that are far more lively than those which come ready-mixed, or than dilute mixes of black. This is especially relevant when painting shadows. I often use a mixture of Cerulean Blue, Winsor Violet and Yellow Ochre. Both Cerulean and Yellow Ochre granulate, which enhances the colourfulness of the grey because as the wash dries individual granules of the separate pigments settle in the hollows of the textured paper. I avoid using bought greys, like Payne's Grey, because they don't separate into individual components of colour and make a less attractive wash.

Wheelbarrow and Mule
320 × 430 mm
(12½ × 17 in)
Although most of these colours are neutral and 'muddy', the tonal contrast and crisp edges make them appear clean and fresh.

WATERCOLOUR TECHNIQUES

When you start using watercolour you will need to practice a great deal in order to learn how to control the paint. Try a few simple exercises, such as applying paint to paper in single washes. Mastering this apparently simple procedure is the foundation of all good watercolour painting and you will only get the hang of it by repeated trial and error, so be prepared to waste a certain amount of paper.

CONTROLLING THE MEDIUM

To learn how to control your wash within a manageable space you should try the following exercises. I suggest that you use a 300 gsm (140 lb) Not surface paper and a large round sable for these exercises – the fewer and broader the strokes, the less risk of streakiness in your wash.

Flat Wash

For this exercise, draw a series of separate three-inch squares on dry watercolour paper; don't bother to stretch the paper first. Then apply a single wash of colour to each square (above right). Get used to how this feels and watch what happens to the colour as it dries. Practice using different quantities of water with your colour and see how this affects the colour, and your handling, of the wash.

Load your brush with plenty of colour. If your brush is too dry, your wash will become broken and streaky and you'll have to scrub to get the paint on to the paper. Don't overload it however, or your washes will become uncontrollable. Position your brush to the left of your square and sweep the colour across it. Without pressing down too hard, make rapid and confident strokes across the paper and try not to work back into a wash. If you don't achieve a smooth wash first time, try again on another shape.

It takes practice to lay a wash successfully, free of streaks or runs. When you are confident with squares, draw more complicated shapes, for example stars or daisies, and try the same exercise, working right up to the line whilst keeping your washes clean and flat.

Graded Wash

A graded wash – a smooth transition from the darker to the lighter tone – takes a bit more practice to achieve. Dampening the paper can help here. Take several small sheets of paper and cover each of them with a simple wash which starts dark at the top and fades to nothing at the bottom. Again, work from left to right, horizontally (if you're right-handed).

Once you have practised these exercises so many times that laying a smooth wash begins to feel comfortable, move on to apply the same technique to simple studies.

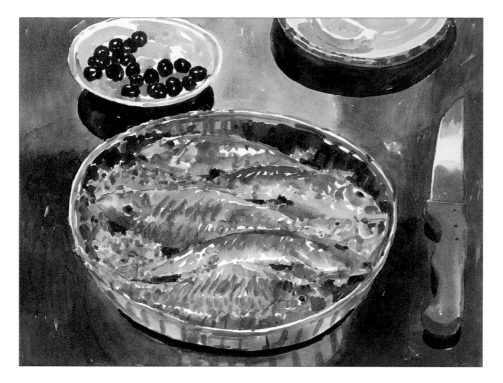

Red Mullet
320 × 430 mm
(12½ × 17 in)
Notice here how small hard-edged white flecks suggest the wet surface of the mullet; the knife handle is a continuous wash with subtle variations achieved by blurring colours wet-in-wet and lifting with a clean, squeezed-dry brush along the right-hand side; the reflection in the surface of the knife blade was softened with clean water.

DILUTING YOUR COLOURS

The amount of water you use to dilute your paint controls the lightness or darkness of your colours by altering their transparency. Mixing plenty of water to achieve pale washes of colour is straightforward, but achieving the right dilution for dark colours and getting your darks dark enough takes more practice. Colours tend to dry paler than when you first apply them, which you should take into account. Avoid putting a dark wash on too strongly, however, as a washed-off dark isn't nearly as attractive as a freshly applied dark which has been allowed to settle undisturbed.

Background tones can be a problem if you want to achieve a continuous area of dark colour whilst working around complex light shapes. It is helpful in this case to start to one side of the background shape and carefully work your wash around to the other side, defining the objects with your brush as you go by painting what is behind them. By doing so you will have less of an edge to continually push along than if you start at the top and end up with both sides on the go at once, which means frantically trying to lay the wash before one side or the other dries too soon.

Primroses
305 × 380 mm
(12 × 15 in)
When painting a background wash, try to mix up enough colour to allow you to work across the entire area – otherwise you will have an unwanted hard edge where the wash dries while you mix up more colour.

For the dark area behind these primroses I started at the bottom left and worked in and out of the flower shapes until I reached the right-hand side.

23

UNDERPAINTING

Some watercolourists apply a light wash to the whole painting, or part of the painting, for example the sky, and work on top of this once dry. I rarely use this method, however, because by doing so you lose the white of the paper for your lightest tones.

Some people like to wet the whole sheet of paper to give a blurred effect to their painting but I find that painting onto dry paper allows you to control your colours and keep the edges crisp and fresh. You can always run one wet colour into another to give a soft transition when a hard edge is not appropriate.

I usually use both methods – wet-in-wet and wet-on-dry – in any one painting. Be careful not to butt two wet washes together if you don't want them to fuse, either by leaving the first wash to dry and working on another part of the picture or by leaving a small sliver of dry paper between the two washes which you can fill in later if necessary.

Study of Pheasants
320 × 430 mm
(12½ × 17 in)
Although painted on dry paper many of the colours of the pheasants were merged together wet-in-wet to give the soft transitions from one to another. Once dry, touches of black gave clarity to the feather patterns.

RESERVING THE LIGHTS

Some artists find that masking fluid is helpful for blocking out small or intricate shapes, such as highlights on water or blades of light grass, before applying a wash. The masking fluid is later removed to reveal white paper in the required shapes. This offers a handy short cut but I am just as happy to paint in and around the lights.

Creating light shapes in this way, by preserving the white of the paper, requires careful planning but for me it is the quickest and most effective way of doing so.

Peach Blossom and Potting Shed Door
510 × 660 mm
(20 × 26 in)
Here, the blossom in front of the dark doorway was left as white paper. I carefully painted round these shapes with the dark wash, later touching the flowers in with the pink.

DEMONSTRATION: TEAPOT

*A*lthough I don't use a pencil to plot my composition before starting a painting, it can be a good idea if you are unsure about going straight in with paint. The pencil marks can be rubbed out later without affecting the watercolour too much. I start by making marks in a pale neutral colour. These help to establish the basic proportions of the composition.

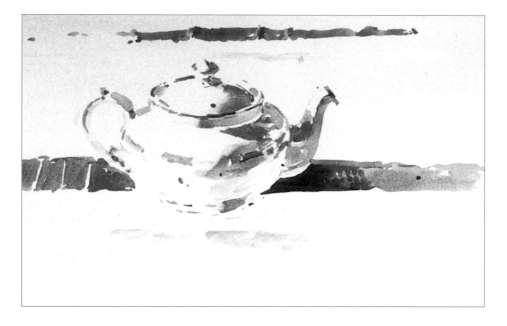

▲ STAGE ONE
I put in the main areas of shadow on the teapot using warm and cool greys. Note that I have left the lightest tone on the teapot as bare white paper, and established the darkest tone of the blue under the teapot spout. This identifies the full range of tones in the painting at the beginning. The negative shapes of the blue stripes of the tablecloth behind the teapot help to draw the base of the spout.

STAGE TWO
I put in the shadow on the tablecloth, let it dry, and then painted the lines of the stripes with Cadmium Yellow. The shadows on the teapot were restated with a darker mix of Cobalt Blue, Alizarin Crimson and Cadmium Yellow. I was careful at this stage not to put any colour on the lightest areas of the teapot.

STAGE THREE
Finished painting:
Teapot
430 × 635 mm
(17 × 25 in)
Throughout the painting, as one area dried I worked on another. For example, as the shadows on the teapot dried I returned to the texture of the tablecloth. In the later stages, it is a matter of building up the detail with the point of the brush – note the finer design on the teapot here. Once everything was thoroughly dry I painted a light blue-grey wash over the body of the teapot, leaving the small highlights to show where the light catches the glaze of the china.

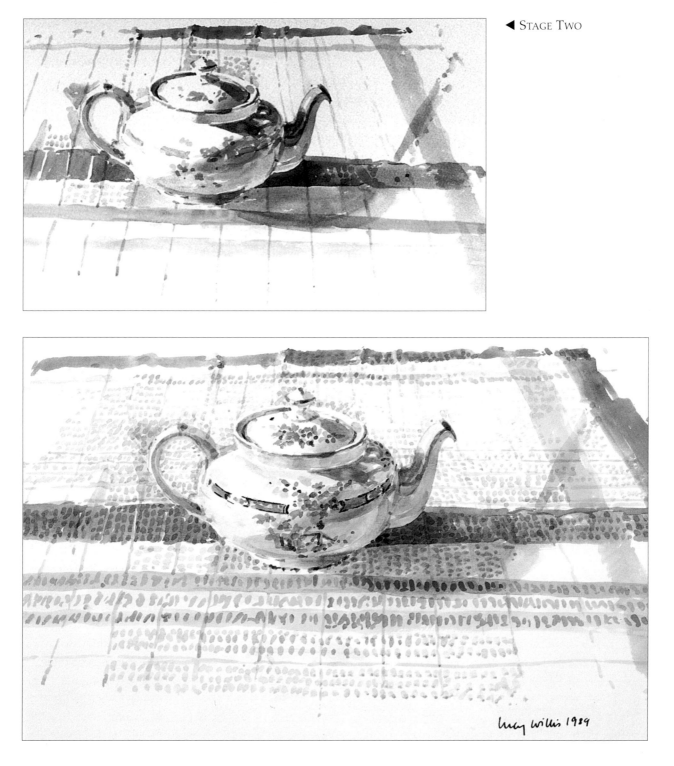

◀ STAGE TWO

▲ STAGE THREE

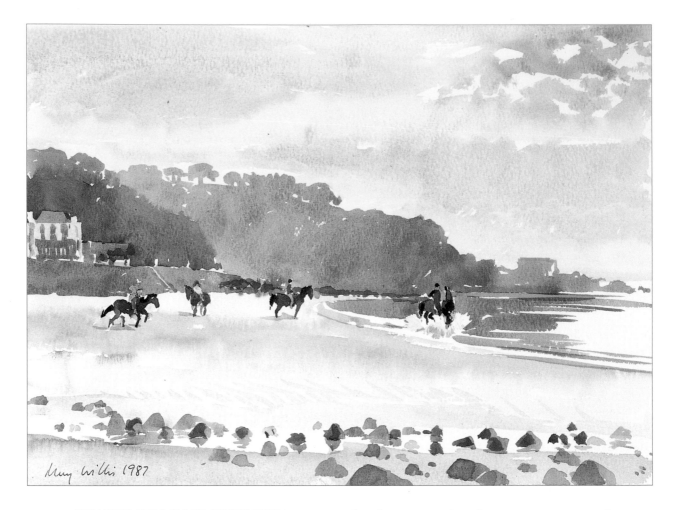

Meg Willis 1987

WATERCOLOUR EFFECTS

One of the attractions of watercolour for me is the way in which certain pigments interact on the paper to produce interesting, granulated washes when the constituent colours separate out. This seems like an accidental effect but it can be controlled with practice and experience. Test to see which colours precipitate on the paper – certain mixtures, and some of the earth colours, are especially prone to do so.

It is important to apply your wash confidently and to let it settle and dry without adding to, or manipulating, it. If you touch it before it is completely dry, you will prevent the separation of colours taking place because the granules of pigment will be disturbed before they settle in the hollows of the paper as the wash dries. Your wash will go flat and you will lose the attractive texture that is an intrinsic quality of watercolour. It is much better to let your wash dry and then if you

decide you need to deepen its tone or colour, apply a second wash and let that dry and granulate in turn.

Backruns
Unpredictable effects often happen in watercolour. When you add a wet wash or drop of paint or water to another, part-dried wash, backruns can occur. The second wash stirs up some of the pigment particles underneath, which then collect at the edges of the wash as it dries to create a pale shape with a fuzzy edge. This is used in a positive way by some artists and can become an effective part of a painting. If you find it happens by mistake, let the backrun dry and see whether it enhances the composition before deciding whether or not to try and get rid of it.

◀ *Horses on the Beach*
255 × 455 mm
(10 × 18 in)
Cerulean Blue precipitates particularly well when mixed with other colours and you can see here how it has granulated in the flat washes of the hills and their reflection in the sea. To capitalize on this effect apply your wash in one go and leave it to settle undisturbed.

▶ *Carmina Burana*
305 × 255 mm
(12 × 10 in)
Here I used black Indian ink with a traditional steel dip pen to draw the upper parts of the singer's body immediately after laying on the loose watercolour washes. The ink ran into the wet watercolour in places along the arms and hand. I left the backruns in the blue washes as they help to suggest the satin sheen of the dress material.

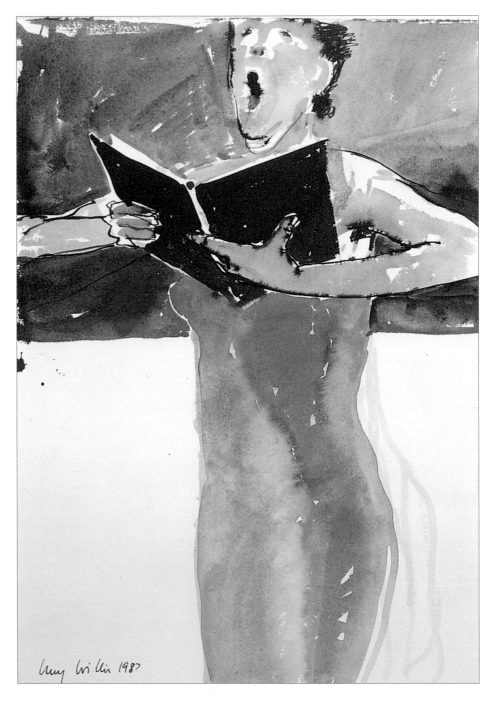

LINE AND WASH

Many artists use pen and ink to enhance their watercolours, either by drawing out the composition first before adding the colour, or by sharpening up a watercolour afterwards. For illustration work the clarity of a strong line can be all-important.

Watercolour can be combined with an ink drawing in many different ways; it need not be just a matter of doing a drawing and then adding colour. I sometimes start with a watercolour wash and while it is still wet I draw into it with pen and ink, creating some interesting effects. Certain inks break up and granulate, while others just bleed into a fuzzy blur when they come into contact with water.

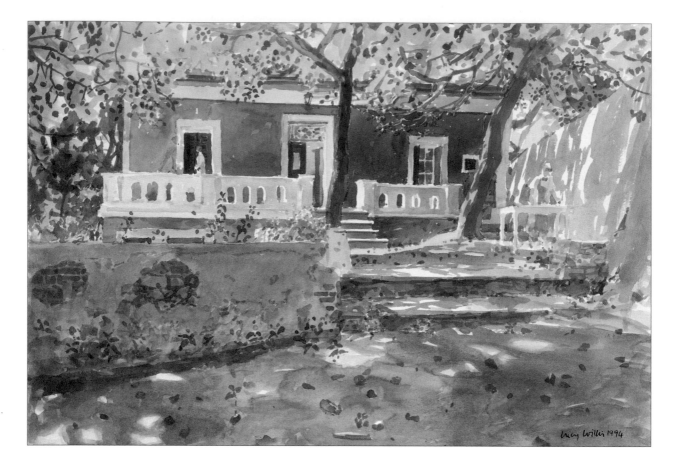

CORRECTING MISTAKES

Minor mistakes can often be successfully incorporated into your painting as you work and you shouldn't worry too much about them; aim for freshness as your first priority rather than absolute accuracy. However, although more problematic, larger mistakes are not necessarily irrevocable and there are many useful measures that can help to put things right. I find that having started with a puritanical 'no corrections' approach to watercolour, I now allow myself to re-work and make changes to paintings a great deal more than I used to.

Remedial measures include lifting out dried colours with a wet brush, sponge or ball of cotton wool and allowing the area to dry thoroughly before painting revisions over the top. With robust watercolour paper you can even take a toothbrush to stubborn colours. However, repainting over thoroughly scrubbed areas often produces an area that is not as fresh as before because a certain amount of

Detail from *Under the Pine Trees*

Under the Pine Trees
430 × 635 mm
(17 × 25 in)
Here, I planned to include two figures on the veranda but later realized that the shapes I had left for them were far too tall. You can just see the ghost of one figure beside the far-left window frame (see detail, left). Rather than completing it I decided to get rid of it by touching it in with the pink of the wall and blue of the shutters, at the same time reducing the light shape of the second figure.

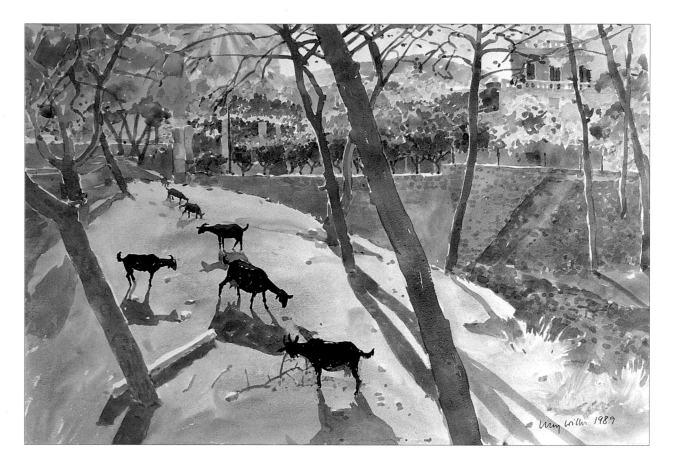

◀ *Evening Light 1*
430 × 635 mm
(17 × 25 in)
I realized that the
composition needed
more interest in the large
empty space. It is
relatively easy to make
such changes in
watercolour by adding
dark elements over a
light background, as you
can see in the final
version above.

▲ *Evening Light 2*
430 × 635 mm
(17 × 25 in)
In keeping with the
Greek subject I added
the goats and, in order to
cover the underlying
colour thoroughly, I
made them black. I then
painted their shadows in
a transparent colour,
carefully matching the
mixture I had used
originally for the
shadows of the trees.

size has been removed and the paper has
become bruised. If washing out doesn't work
sufficiently, opaque body colour can be used to
make things lighter and give the required
brightness, although it never gleams in quite
the same way as pristine white paper. This is
especially useful if you want to move or alter
something in a painting. Making things darker
is much easier than making them lighter
because you can more successfully apply dark
colours over the top of dry, lighter colours.

WAYS INTO WATERCOLOUR

Drawing is the most obvious foundation for learning to paint in watercolour and its importance cannot be overstressed. It helps to develop your observation skills and ability to translate what you see into the right shapes, tones and proportions. It is particularly crucial in watercolour because, as we have seen earlier, making changes is a tricky business and will often compromize the clarity of your paintings.

SKETCHING AND DRAWING

Nothing beats regular drawing practice, so carry a sketchbook and draw anything and everything whenever you get the chance. It doesn't matter what you draw; it requires the same basic skills to draw a jug accurately as it does the human figure. Practice as often as you can, even if only for fifteen minutes each day.

Think of it as an opportunity to discover and solve problems; adjusting and correcting the proportion and position of objects is an all-important part of the process. And as a preparation for painting light, making tonal drawings is especially important because this teaches you to judge tonal values accurately. It is a handy way of recording information when you haven't got the time to paint a watercolour.

Preliminary Drawings

Although I don't usually do so, it can be a good idea to begin by making a light skeleton drawing before starting a watercolour, plotting the main shapes on your paper. This will give you the confidence to approach your painting boldly without worrying about whether things are in the right place; you will have established this already with pencil and eraser. But don't overelaborate and try to include too much detail at this stage, otherwise the painting can become just a 'colouring-in' exercise.

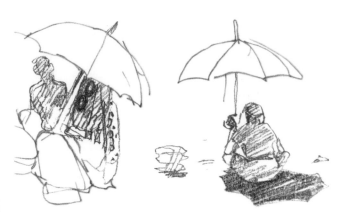

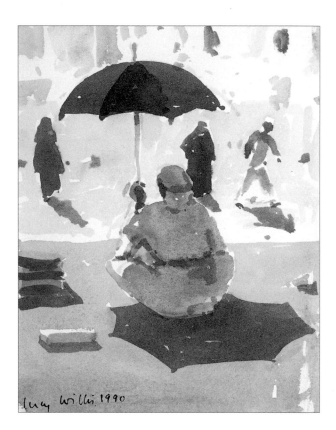

Man with an Umbrella, pencil study and watercolour *255 × 180 mm (10 × 7 in)* I looked through my Yemen sketchbook back in the studio and, as I had been intrigued by this figure sitting in a pool of shadow under his umbrella (top), I decided to use this study for a small painting. The two or three tones in the sketch gave me enough information to translate the study into watercolour (above).

Photographic reference for *At the Water's Edge*. This photograph was taken from a moving boat. It would have been impossible to have made a drawing or painting in these circumstances.

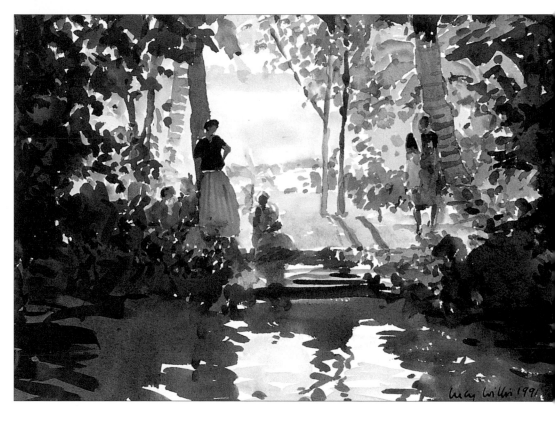

At the Water's Edge
320 × 430 mm
(12½ × 17 in)
The painting from the photographic reference was completed back in the studio in a very short space of time in order to avoid overworking it and to give the impression of spontaneity.

It can be an advantage to work from out-of-focus photographs, as in this case, because you are less likely to include too much unnecessary detail.

USING A CAMERA

I resisted working from photographs to start with because they can tempt you to keep working on a painting until you finish up with a composition that looks too photographic. But I now believe that you can avoid this if you aim to use photographs in a similar way to your sketchbook: as a means of recording information, such as fleeting light effects, or a moving subject.

Be aware of the fact that the camera very often alters tones. It reacts differently to large areas of shadow for instance, sometimes 'seeing' more or less light in them than the eye does. A tonal sketch can be more reliable.

If you do use photographs, be tough on yourself and only select the information that you would normally look for when working on the spot. Try to recreate the same sense of urgency, and discipline yourself to finish painting at the point when you might have stopped when working direct from the subject. Working under pressure contributes a liveliness to a painting and one of the dangers with using photographs is that you are likely to adopt a more relaxed, less selective attitude.

THE
IMPORTANCE
OF TONE

The tonal structure of a painting is the foundation on which a composition rests; it brings it to life. So for the portrayal of the effects of light, you must first understand the importance of analysing the subject in terms of the lightest and darkest tones, and the mid tones in between.

As artists we have available to us a much narrower range of tones than exists in nature and the brilliance of bright light is far greater than the lightest tone at our disposal – the white of our paper. So to create the illusion of that brightness, we must exploit tonal contrasts to the full. In this chapter we will explore how to see and analyse tone and tonal relationships, and how to translate these into watercolour.

Man at a Sewing Machine
510 × 335 mm (20 × 13¼ in)

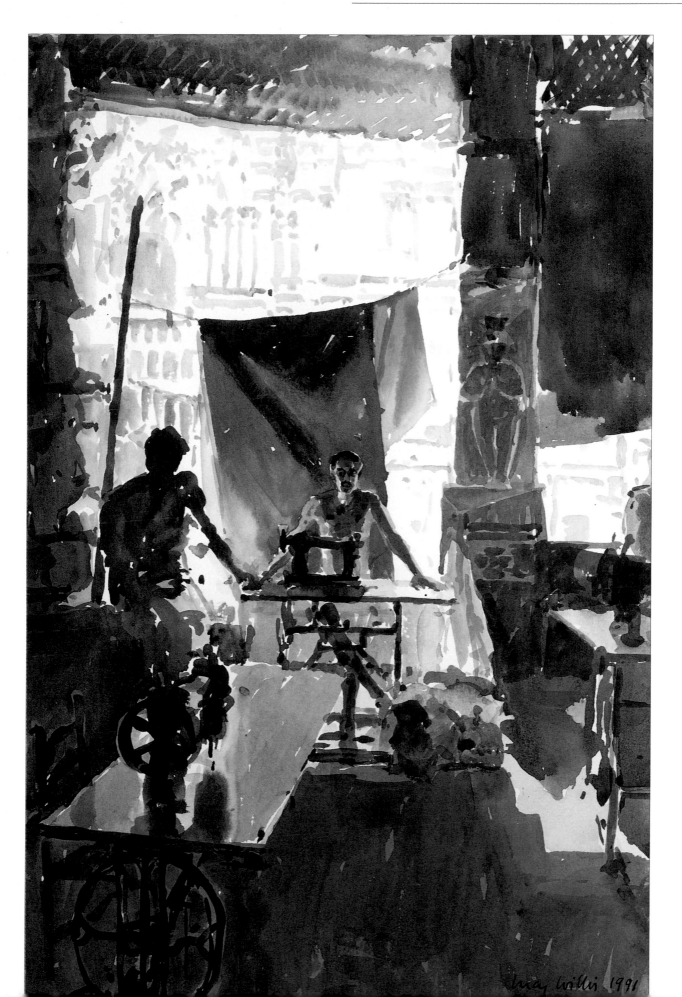

WHAT IS TONE?

In simple terms, tone is the relative lightness or darkness of something, regardless of its colour. This is easier to understand if you look at the black and white photographs in your newspaper for example, which reduce a subject to its pattern of light and dark tonal contrasts.

A good exercise to help you to get used to judging tone is to make a tonal scale, like the one shown below, grading tones from light to dark. This gives you something with which to gauge the tones of your subject. Another useful exercise is to cut a narrow strip from a colour photograph in a magazine or newspaper and to translate this into a strip of tones of black, white and grey as accurately as possible.

A tonal scale

A good method for assessing the tones in your subject is to half-close your eyes, which helps to minimize your perception of colour and enhance your perception of tone. It also helps to reduce the amount of distracting detail that you see, so that you can concentrate on the broader pattern of light, dark and mid-tone shapes.

Brick Study
205 × 255 mm
(8 × 10 in)
Painting a simple object like this brick can help you to see and translate tone into watercolour, as well as practise handling the medium.

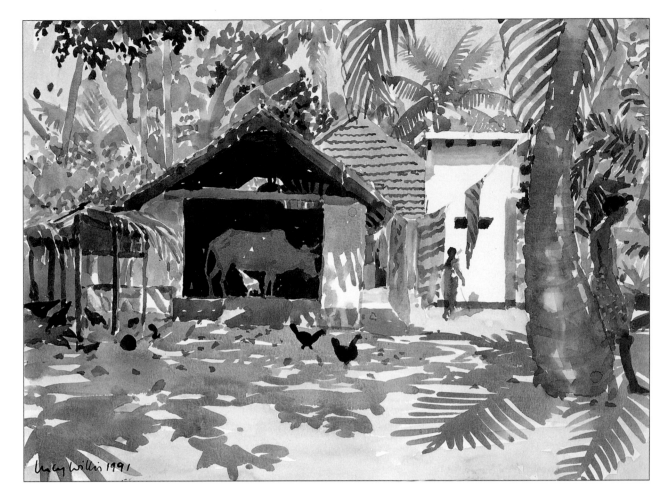

LIGHT AND TONE

The tone of any object, of whatever colour, is affected by the intensity and play of light on it. In effect, light changes what we think we know about a colour and its tone, so we must be prepared to set aside our preconceptions and rely on careful scrutiny of the subject in order to learn how to separate the tone we see from the colour we know an object is. Look at the study of a brick (shown left) and notice the range of tones – from white on top to dark on the side – in what we know is essentially a mid-tone brick red colour.

The Cowshed
320 × 430 mm
(12½ × 17 in)
Our judgement of tone can become confused by what we already know about the local colour and tone of things. For example, the cow in this painting was white and I had to set aside my understanding of its actual colour in order to see the darkness of its tone in the deep shade of the cowshed. Contrast this with the brilliance of the white chicken in the sunshine outside.

TONE, FORM AND VOLUME

One of the most important reasons for learning how to analyse your subject in terms of light, dark and mid tones is that it equips you to render objects realistically and give the illusion of three-dimensional form and solidity, even though in reality you are working with shapes of tone and colour on a flat surface.

The illusion of the rounded form of the egg in *Geranium and Goose Egg*, for example, depends on the subtle juxtapositions of the dark, light and mid tones to express its volume. The pale tone near the outer edge of the shaded side of the egg is the reflected light bouncing up from the light-coloured surface into the shaded area. Notice, too, in *Striped Armchair by a Window* (opposite) how the light strikes the tops of the chairback, arms and seat, and the way in which the tones are graduated to give the effect of roundness. Such tonal gradation is crucial to the rendering of solid objects.

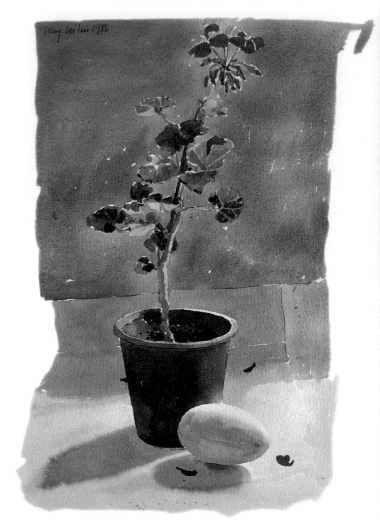

Geranium and Goose Egg
305 × 205 mm
(12 × 8 in)
Each voluminous shape here has a light and dark side, with an area of gradated half tone in between.

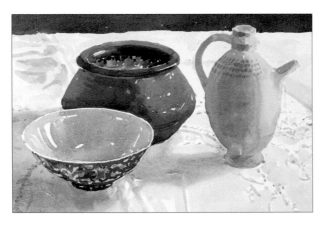

Detail from
Abu Dhabi Bowls
430 × 635 mm
(17 × 25 in)
Notice in this still-life study how the tonal contrasts give the objects their three-dimensional form and how the light affects both the tonal values and intensity of the muted colours.

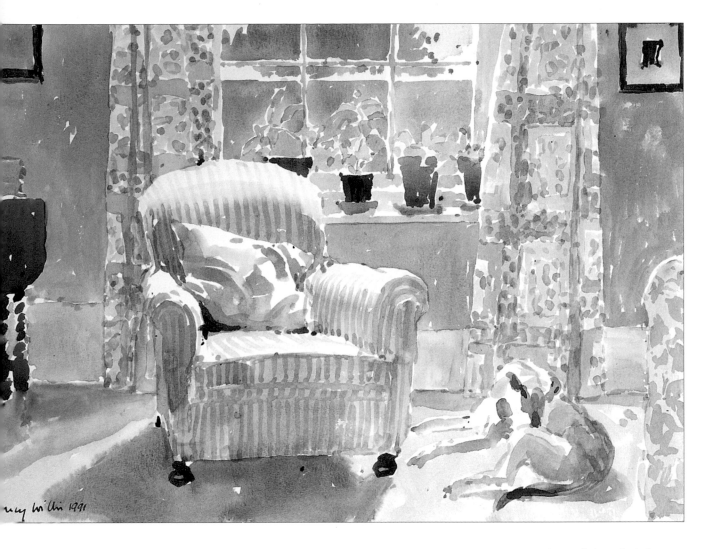

Striped Armchair by a Window
320 × 430 mm
(12½ × 17 in)
Hard edges describe the outer contours of the armchair while the gently curved planes of the tops of the chairback and arms are defined by subtly graduated tone. The colour of the green stripes of the armchair fabric disappears altogether where the light from the window strikes it.

MAKING TONAL STUDIES

Making black and white tonal drawings is one of the most useful practices for artists. While line drawings are enormously useful for learning about proportion and composition, a purely tonal drawing is more like a painting. Using the change of tone to define the edges of objects instead of a line is similar to the watercolourists' approach of juxtaposing areas of colour. When working from observation we must learn to select and simplify the profusion of detail in front of us and tonal drawings offer us the means of doing so because they encourage us to concentrate on the main shapes and tonal masses.

When you start a tonal drawing, remember to half-close your eyes and carefully break down the subject into, say, three main tones: you can leave the white of the paper for the lightest tone, the darkest black you can achieve with a pencil for the darkest tone, and a grey mid tone. You can then work back into this simplified drawing by concentrating more on the subtle tonal variations in between these three.

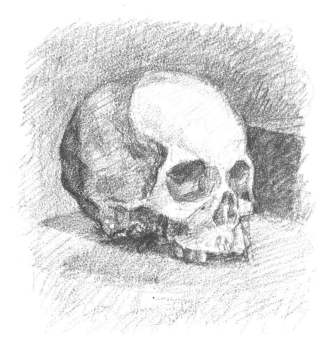

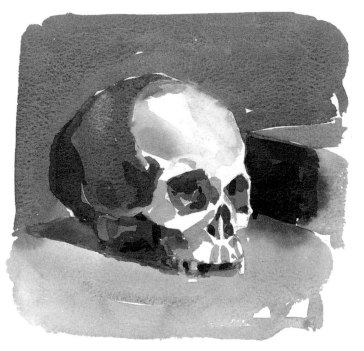

Skull I
pencil tonal drawing
255 × 255 mm
(10 × 10 in)
To practise making tonal drawings choose a voluminous object. It doesn't have to be as complex as a skull: an orange or egg will do. Try to define the edges of the object by tonal contrasts rather than by using lines. Here, the back of the skull is darker than its background, towards the middle it is the same tone and its front is much lighter; every plane and facet is defined by its tonal relationship with its neighbours as well as with the mid-tone background.

Skull II
watercolour
255 × 305 mm
(10 × 12 in)
Painting a monochrome study in shades of black or brown (I used a mixture of Ivory Black and Cadmium Red here) can help you learn to use tone in watercolour without the complications of colour. Whether you paint your study from your tonal drawing or from the subject itself, try and match the tones without too much overpainting.

TONAL EXERCISES

Preliminary tonal drawings also provide you with an ideal opportunity to become familiar with your subject before embarking on a painting. They will help to sharpen your perception and increase your confidence and understanding. You can take your time working out tonal relationships in pencil before committing them to watercolour.

It can then be a good exercise to make monochrome watercolour studies. This gets you used to handling the medium through a tonal analysis of the subject, without the added problem of colour, and colour relationships. Practise on a small scale and adjust your tonal values by varying the amount of water you mix with your colour – lots of water for your lighter tones (leave the paper white for the brightest tones); not very much water for your darks. You may have to reinforce your darks by overlaying another wash when the first application is completely dry. Again, avoid unnecessary detail and simplify your subject as this will help clarify the impression of light and form.

TONAL COUNTERCHANGE

Counterchange – the placing of light shapes against dark and dark against light – can be used to great effect in paintings to enhance the impression of light and to define one object against another, as in *Margueritas in a Blue Glass Bottle* (above right).

Aim to look for the interplay of tonal contrast and tonal similarity (sometimes referred to as 'lost' and 'found' edges) as this helps to describe the more subtle effects of light. Edges of objects become 'lost' where the tones of an object and its background are equal; a 'found' edge occurs where an object is defined by tonal contrast against another object or its background. Also, in black and white drawings the tones of adjacent objects often run into each other resulting in lost edges, but when you paint them the definition comes from the change of colour, not tone.

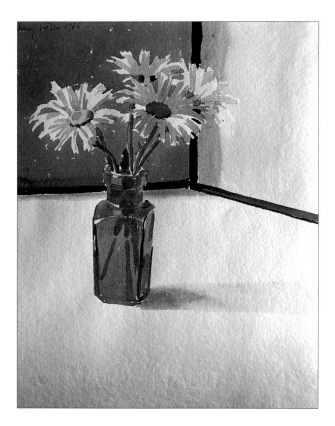

Margueritas in a Blue Glass Bottle
255 × 180 mm
(10 × 7 in)
Remember when setting up a still life like this that the tonal pattern of your subject is an important compositional consideration. Here, the shapes of the white flower heads are more clearly defined by their placing against the dark background. Although the local tone of the background is white it is in shadow and therefore appears dark grey, throwing the daisies forward in sharp contrast. The relationship is reversed lower down where the bottle is darker than the surface on which it stands.

41

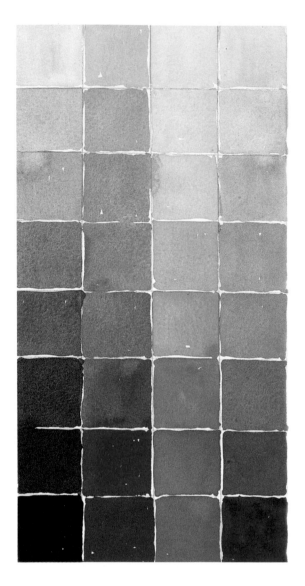

Colour and tone chart

TONE AND COLOUR

It is one thing to understand tone in terms of black, white and grey, but quite another to relate this to colour. The tone of a colour describes its lightness or darkness, so although Cadmium Red and Cadmium Red Light are the same hue, they are different in tone.

It can be surprisingly difficult to judge the tone of colours because we tend to be more receptive to different hues than to their relative lightness or darkness. However, it is important to learn to identify their various tones in order to give the impression of light and with practise it becomes second nature to see things tonally.

To practise judging the tones of your colours, make a colour and tone chart by drawing a grid divided into 32 square-inch boxes, consisting of eight rows and four columns. Down the first column make a nine-tone grey scale, starting with white at the top and finishing with black at the bottom, with an even gradation of grey tones in between. Using pure, unmixed colour from your chosen palette, fill in the squares of the three remaining columns, matching each colour to the relevant tone on the black and white scale. Check by half closing your eyes to see if they are equal, or is there a tonal contrast? This can be an instructive exercise, which will also help improve your control of the paint, especially as you don't have to worry about relating your colours to a subject. However, notice that none of the colours will reach the darkness of black at the bottom of the scale.

TONAL RELATIONSHIPS

Colours interact with each other and the addition of every colour to a painting modifies the relationship of colours already applied. For example, a dark tone will appear even darker when juxtaposed with a light tone. Many watercolours lack sparkle and punch because

Turquoise House
430 × 635 mm
(17 × 25 in)
Here I was confronted with strong local colour but had to modify the tones in order to create the effect of the sunlight on the building. The local colour of the house was a bright turquoise blue, but under the Indian sun the areas of the walls under the veranda that were in shade were a deep, dark blue; the parts of the walls in shadow from the overhanging roof were a mid-tone blue, while the blue of the areas directly affected by the light was almost bleached out. The intensity of the darkest tones in the painting enhances the impression of light.

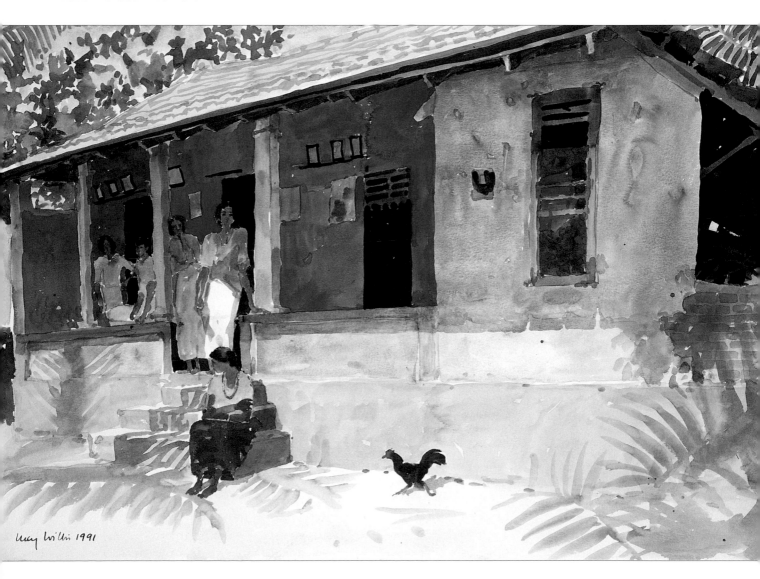

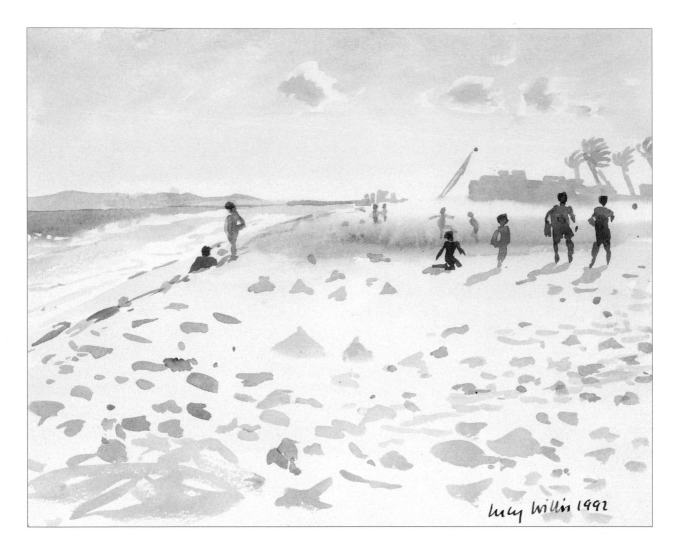

the light tones are not light enough or the darks dark enough, and they have a rather restricted mid-tone range. So it is important to register your darkest and lightest tones in your mind's eye before you begin, and remember that watercolour dries lighter than it appears when wet. Don't worry that you may have to sacrifice the intensity of the colour in order to achieve the appropriate depth or lightness of tone. You will find that the resulting impression of light in your painting will make up for it.

It is helpful at the beginning of a painting to map the edges of your lightest tones with a pencil or pale marks of watercolour, and to leave these as white paper until the end, when you can add a tint of colour if necessary. Having decided where your darkest darks will be, you can paint them in. Don't be afraid to make them really strong. This, combined with

the white of the paper for the lightest tones, will give you the full tonal range and once the lightest and darkest areas are in place you can build in the mid tones.

Alternatively, you may find it less daunting to begin by laying in broad areas of mid tone – not forgetting to leave the whites – and working into these when they are thoroughly dry with more darks. This will ultimately achieve the same tonal effect though possibly at the expense of the freshness of your watercolour if you overlay too many times.

Whichever way you choose to proceed try to work on all areas of the painting in turn, constantly comparing one tone and colour to another, relating cool to warm, light to dark. Build the composition in a continuous process of judging shape, colour and tone across the whole picture. In watercolour this approach is particularly suitable as certain areas will need

◀ *The Beach, Salalah*
320 × 430 mm
(12½ × 17 in)
The strong contrast of the
dark silhouetted figures
seen against the diffused
light tones of the beach
and sky conjours up the
effect of the evening
light and seaside
atmosphere.

▶ *Child Asleep under*
a Window
430 × 320 mm
(17 × 12½ in)
The range of tones is
mainly at the lighter end
of the scale in this high-
key painting. The stronger
tones are kept to a
minimum, although those
of the table leg and
child's hair provide a bit
of contrast to punctuate
the overall delicacy of the
rest of the painting.

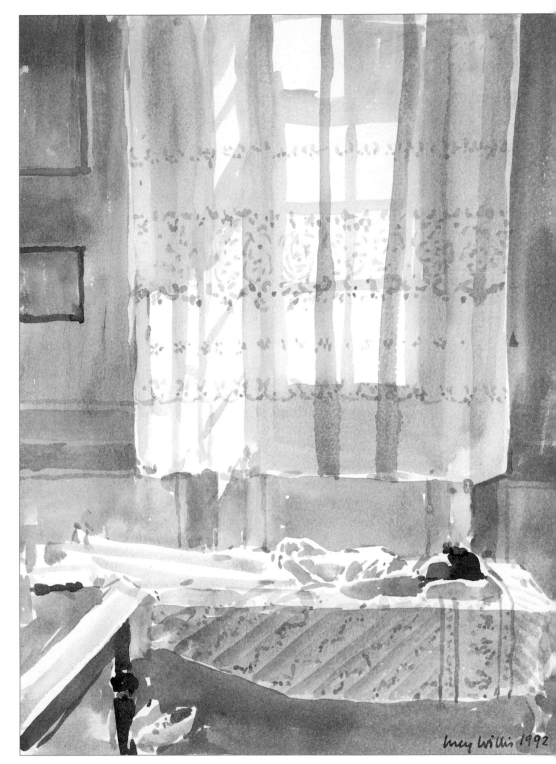

to be left to dry before being juxtaposed with
the next wash. Look for wherever the same
colour or tone crops up in other parts of the
composition and put them all in while you
have that mixture on your brush. By doing so
you will relate tonally all the different areas of
the picture and not just those near each other.

LIGHT
AND
SHADOW

The different manifestations of shadows seem endless when you begin to notice them. They can be sharp, soft or dappled and an infinite variety of colours and tones. They tell us about the direction and quality of the light, help to define form, surfaces and planes, and can become a significant compositional element in a painting, as important as the subject itself. Most significantly of all, shadows are perhaps the single most evocative way to suggest a feeling of light and atmosphere.

Here, we will examine how to see the strengths and subtleties of shadows and look at their various roles in creating a convincing impression of light, form and space.

The Rubbish Collector, Hodeida
430 × 320 mm (17 × 12½ in)

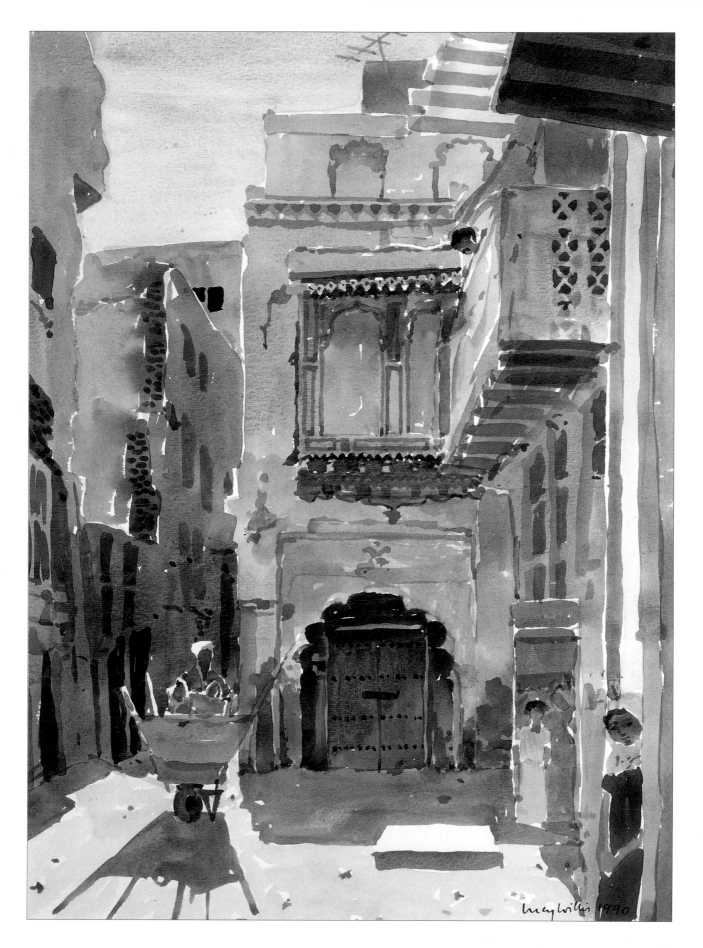

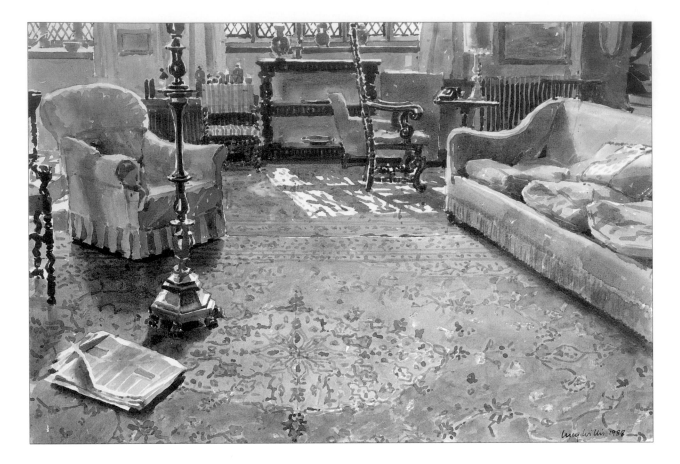

LOOKING AT SHADOWS

Although intangible, shadows are such an integral feature of our environment that they should be treated by the painter with as much importance as anything else. Assess their tone, colour, shape and quality of edge just as you would any other element. Some shadows are 'cast', others are 'attached' to a surface, or a surface might be 'in shadow'.

The nature of shadows, their shape, colour and tone, is affected by the source of light and whether this is natural or artificial, bright or diffuse. Bright sunlight casts strong, contrasting, clearly defined shadows while shadows cast by diffuse daylight are softer and have less defined edges. The weather, time of day and season can also affect the appearance of shadows. By contrast, electric light casts stable, consistent shadows but even these vary enormously according to the type and position of the light source. If you look closely you will see that shadows also absorb and reflect colour and light; they need not be just a darker version of the rest of the picture.

THE SUN AND SHADOWS

Cast shadows must all be consistent with the light source: they must all go in the same direction away from the light. It is important, therefore, when you are painting shadows cast by the sun, which change as the sun moves, to plot their position early on in the painting, and to understand how to construct them accurately. Even with interior subjects, the shadows and light patterns cast by sunlight through a doorway or window can quickly diminish, disappear or change angle as the sun moves round. Don't work for too long on your painting once the light has changed, and if possible return to it at the same time the next day when the sun is casting the same shapes and intensity of shadows because the light will be very different at various times of day.

◄ *Sunday*
430 × 635 mm
(17 × 25 in)
Most of this interior is in shade, but the sunlit shapes cast by the sunlight through the window had to be plotted quickly before the angles changed as the sun moved round.

Raja on a Rock
320 × 430 mm
(12½ × 17 in)
The side of Raja's body away from the light is in half-shadow, while his shape also casts a shadow over the surface of the rock on which he is perched.

When looking at cast shadows it may help to think about the way shadows are formed: as the sun's rays strike the earth, an object that blocks these rays will obviously cast a shadow on the opposite side of the object to the direction of the light. This means that the area of the object between the light and the shadow will also be in shadow and the attached shadow will start at the base of the object and end where the rays of light pass over.

The height and angle of the sun will determine the length of the shadows. For example, when it is at a 45 degree angle to the horizon, the shadows cast will be the same length as the height of the objects that cast them. When the sun is high, cast shadows on the ground are short; when it is low they are much longer. This effect is distorted, however, where the land on which the shadows are cast is sloping, as seen in *Raja on a Rock*.

HARD AND SOFT EDGES

Look, too, for the quality of the edge of shadows. This depends on the intensity of the light source, and the distance of the object casting the shadow from the surface on which it falls. Shadows created by strong light have clear, crisp edges when cast onto a near surface, but these blur somewhat when the surface is more distant. Note the difference between the edges of the shadows in *China in Sunlight* and *China in Soft Light*. Here the difference is the result of different kinds of daylight: direct sunlight and diffuse, ambient light.

I find watercolour an ideal medium for representing this diversity. A strong mixture applied to dry paper in the required shape will give the crisp edge of a sharp shadow whilst the soft edges of shadows cast by diffuse light or distant objects can be achieved by first painting the shadow then, while it is still wet, loading your brush with clean water and running this around the contour of your shadow shape, which will fuse into the water. Practise looking at, and painting, shadows cast by different intensities of light by setting up a simple still life, similar to the two studies shown opposite, and painting this first when the light is bright and strong and then another version when it is softer and more diffuse. Notice the effect this has on the composition and atmosphere of your picture.

THE COLOUR OF SHADOWS

When you begin to look at the colour of shadows you will find that they are often subtly colourful, although perhaps muted. Don't make the mistake of painting shadows black or grey; there is a danger that your painting will look 'dead'. Heavy, dark shadows can destroy the more subtle suggestions of form and light. The Impressionists laid great stress on their observation that shadows are rarely just grey but comprise varying hues due to their contrast and relationship to the colours in their environment.

China in Sunlight
320 × 430 mm
(12½ × 17 in)
Compare this study with *China in Soft Light* and notice how the edges of shadows cast by strong direct light are more precise than the edges of those cast by diffuse light.

China in Soft Light
320 × 430 mm
(12½ × 17 in)
The shadows here are soft-edged because the light casting them is more diffuse. The blurred edge was achieved by running a clean wet brush around the painted shadow and letting it bleed outwards.

Doorway with Doves
430 × 320 mm
(17 × 12½ in)
The strong hard-edged shadows cast by the sun contrast tonally with the bleached, brightly-lit wall to emphasize the intensity of the light in this scene. Note how the shadows falling across each of the open doors help to define their angles.

The key to painting shadows, as with everything, lies in careful observation. Look for warm and cool colours even in the darkest shadows. Although it is often true that the colours of shadows are simply a darker version of the local colour – the shadows of the doors in *Doorway with Doves* are a darker shade of the wood, for example – they also sometimes contain tints of the colour complementary to the local colour of the objects themselves – as in the top left-hand corner of the shadow on the wall.

The colour of shadows can also be influenced by the colours of objects around them – or by the reflection of the blue of the sky on a sunny day, as above. In this way a shadow cast by the sun onto a white surface, such as snow, will appear blue in contrast to the warmer sunlit surface.

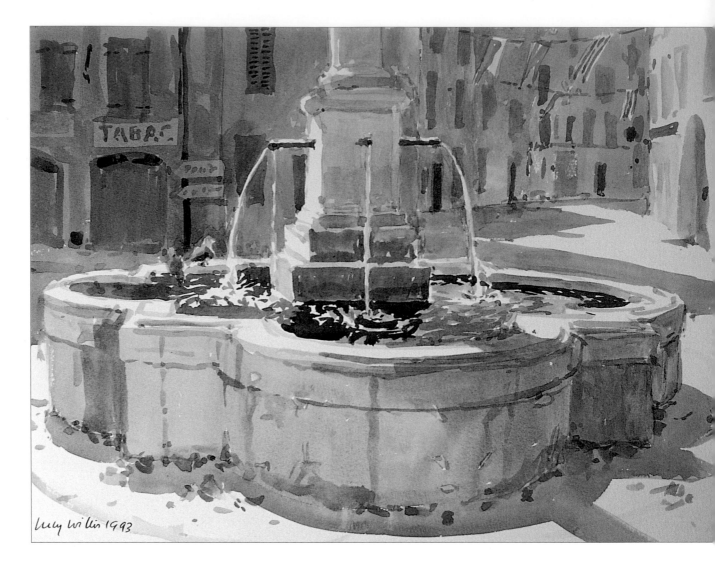

Lucy Willis 1993

REFLECTED LIGHT

Within shadows you will often notice a lighter tone or warmer glow of colour where the light bounces off a nearby strongly lit object or surface, subtly illuminating the shade and enriching its colour. Light-coloured objects or surfaces tend to reflect the light most, as in the demonstration study of the archway on page 54, for example, in which the light is reflected from the sunlit ground onto the pale underside of the arch, creating a rich yellow area in the cooler shadow which runs around the inside of it. Notice when looking for the effect of reflected light how its colour tends to be warmer than the colour of the rest of the shadow. This happens not only in bright sunlight but also when the light is softer and more diffuse.

La Foux
320 × 430 mm
(12½ × 17 in)
Here the light is reflected from the sunlit ground onto the left-hand side of the fountain which, because its local colour is the beigey-white of stained marble, accepts a myriad of colours.

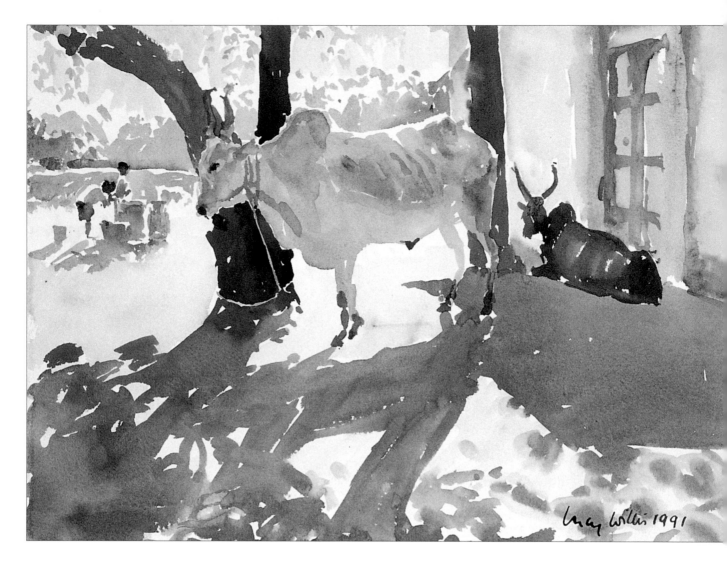

Also remember that an area of reflected light is never as light in tone as the area struck directly by the light source, even though it may be lighter in tone than the rest of the shadow in which it falls. You will upset the balance if the reflected light competes with the other lightest tones. You can practise painting these subtle changes easily by placing an egg on a white piece of paper in various light conditions: by the window, under a table lamp, in sunshine. Half-close your eyes to clarify the tones and notice the tonal changes on the underside of the egg and within the cast shadow. A thorough understanding of this will contribute to a convincing sense of light and form in your paintings.

Cows under the Trees
320 × 430 mm
(12½ × 17 in)
The warmer colour reflected from the ground can be clearly seen in the underside of the main cow in this painting. At the same time, a cool bluey purple light from the sky is reflected by the upper curving planes of the cow's body.

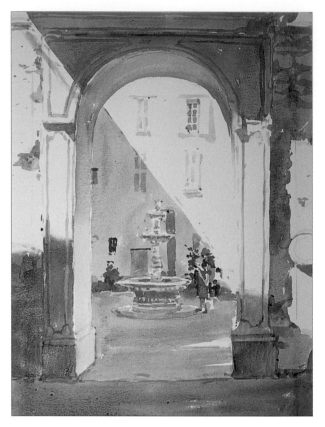

*H*ere, I was intrigued by the alternating pattern of shadows and the complementary play of warm and cool colours created by the reflected light under the archway.

▲ STAGE ONE

Using a mixture of Yellow Ochre muted with leftover colour from my palette I made a series of preliminary marks to plot the position of the arch, fountain and angle of the diagonal shadow. Once satisfied with this preliminary 'drawing' I started on the right-hand shadow with a grey wash made from Cerulean Blue and Winsor Violet and introduced patches of Yellow Ochre.

I then washed in larger areas of shadow, leaving some edges hard (the diagonals) and softening others with clean water (bottom left). The reflected light under the top of the arch was particularly strong and yellow but I cooled it with a more neutral grey for the inside left.

▲ STAGE TWO

All the shadows were now in place and, once dry, I began to introduce some of the architectural detail and stonework as well as the suggestion of figure and plants. The shadow angles had changed considerably since the start of the painting so I then decided to stop.

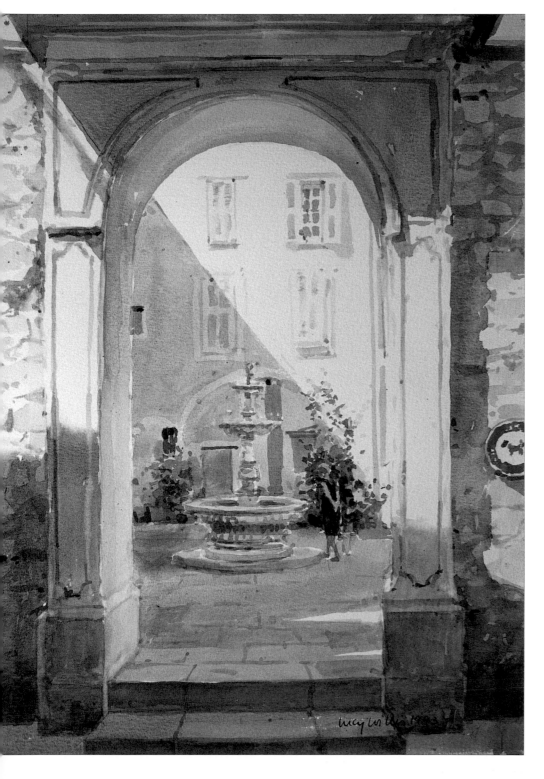

◀ STAGE THREE
Finished painting:
Archway
430 × 320 mm
(17 × 12½ in)
Back in the studio I
added the last few darks
to suggest the stone
steps, the paving and
some other final details.
I also darkened the
ground to the left of the
fountain to accentuate
the pale reflected light
on the inside of the
archway where it picked
up the sun from the
opposite side. I decided
to leave the sunlit areas
on the front of the arch
and the far wall white to
keep them well above
the tone of the palest
shadows. Note how the
glow of the reflected
light in the shadow of
the arch has been
achieved by surrounding
it with the tonally
darker area of Cerulean
and Winsor Violet
mixed with touches
of Cadmium Red
and Cadmium Yellow.

PAINTING SHADOWS

The transparency of watercolour is ideally suited to painting shadows. You can wash right over an area of a picture with a shadow tone and the detail will still show through while the feeling of light will be magically increased – or you can put the shadow in first and add the detail on top once this first wash is dry. Whichever approach you take, larger shadows often need to be laid down as flat, clear shapes, albeit with variations within, so you must have your medium comfortably under control before you start.

Aim to mix the right depth of tone and colour of a shadow, so that you do not have to apply a second wash if you can help it. As I have mentioned, you should try to avoid disturbing your first wash as this can result in muddy colours, and kill the luminosity you are trying to achieve. You can merge colours wet-in-wet, however, where you see subtle nuances of colour within the shadow. If you feel happier, draw a pencil line around the shadow shapes before you begin, especially when they are fairly complex.

Make sure you mix up enough of the correct colours on your palette so that you can apply your wash directly; test these on a separate sheet of paper if you are uncertain about them, remembering that colours dry somewhat lighter than when first applied. Consider the shape, colour and tone of your shadow, and the quality of its edge, as discussed earlier. When everything is ready and you have prepared your plan of action lay your shadow down as a single wash and leave it to dry.

Asleep on the Sofa in the Sun
255 × 380 mm
(10 × 15 in)
Here, if you look at the foreground shadow especially, you can see how the warm colours on the left, which is where I started my wash, blend into the bluer, cooler mixture as I moved the wash across to the right.

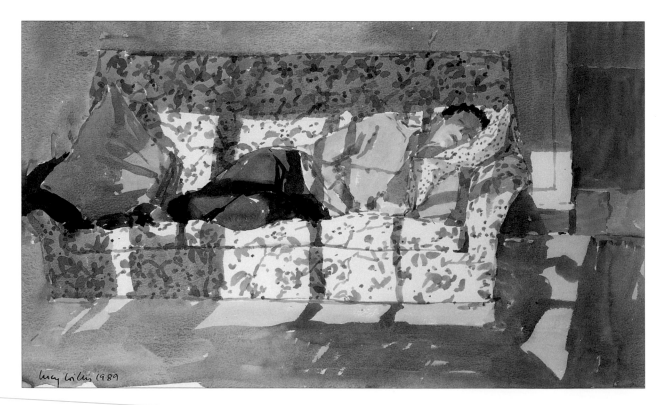

Lucy Willis 1989

DAPPLED SHADOWS

Underneath trees, on the ground or across
buildings, you will often see a marvellous
confusion of light and shade. This may seem
daunting to paint but a dappled shadow in
watercolour is basically a wash with lots of
gaps in it. It is important to try and paint a
dappled shadow in a single wash, which can be
tricky as you must consider not only the
complex pattern but also, when cast onto the
ground, its receding perspective where the
gaps get smaller in the distance. You must also
make sure that none of the edges dry too
quickly to leave too hard an edge. Sometimes
the edges of dappled shadows are soft and
indistinct, which can mean blurring the edges
of each of the 'gaps' as well as the outside
edges before they dry by running a clean, wet
brush along them.

*Sunday at the
Boys' Home
430 × 635 mm
(17 × 25 in)*
The converging lines and
angles of the sharp-
edged, dappled shadow
cast by the tree in the
foreground lead the eye
into the brightly lit
middle distance and
contribute to the sense of
space in this painting.

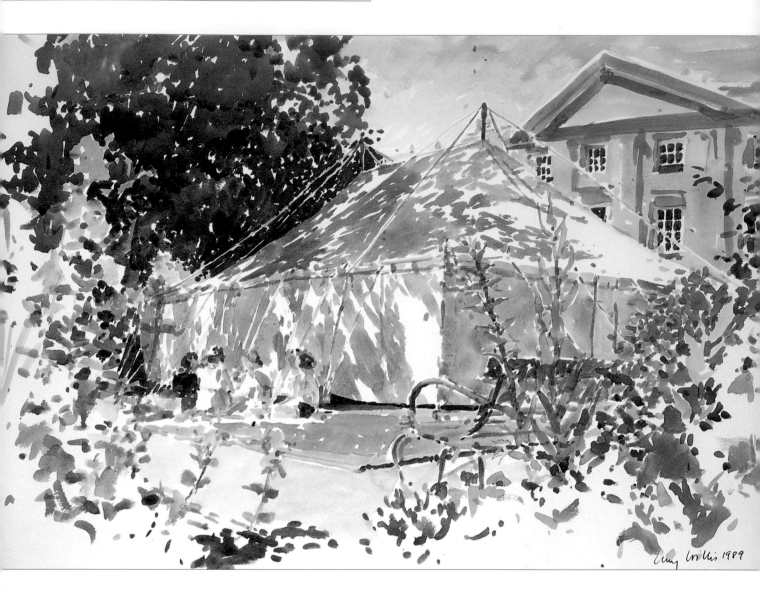

THE FUNCTIONS OF SHADOWS

Shadows enhance the illusion of light; they can help to describe the space and distance in a composition, and they can give weight and solidity to an object and anchor it to the surface or plane on which it stands. Shadows also help to define the form of objects they fall across by describing their planes and angles.

It is important to be aware that shadows conform to the laws of perspective, as we saw earlier when discussing dappled shadows, but it is perhaps easier to see this when you look at buildings and their shadows. If a building recedes away from you the horizontal lines of

The Marquee
430 × 635 mm
(17 × 25 in)
Shadows wrap themselves round objects and help to suggest the volume of forms, such as this marquee, by describing the planes and angles. Notice how the shadow colour changes from the blue on top, received from the sky, to the warmer colour on the sides, picked up from the ground.

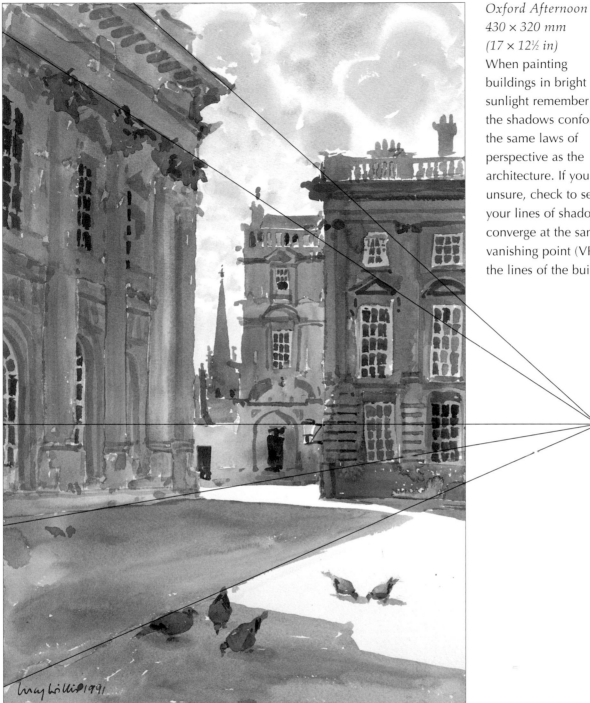

Oxford Afternoon
430 × 320 mm
(17 × 12½ in)
When painting
buildings in bright
sunlight remember that
the shadows conform to
the same laws of
perspective as the
architecture. If you are
unsure, check to see if
your lines of shadow
converge at the same
vanishing point (VP) as
the lines of the buildings.

VP

its roof and base will converge at a particular
vanishing point and you will find that the
edge of the shadows cast by the top of the
building will recede to this same point.

The same effect can be seen in *Sunday at
the Boys' Home* on page 57, although it is
more elusive here because of the irregularity
of the dappled shadow. But notice that the
shadow of the rickshaw is heading towards

the same vanishing point as the perspective lines of the building on the left because the sun is straight ahead of us.

Areas of shade and cast shadows also create exciting, almost abstract light/dark patterns that can suggest powerful compositional designs. Bear this in mind when looking for a subject to paint. Take *Children of Sana'a*, for example. On an overcast day when the light is flat, this scene may have been less interesting, but it was transformed by the dramatic shape of the cast shadow across the ground and building facade. Shadows can become as much the subject for a painting as anything else, as seen in *Asleep in Istanbul* (above right). Here the shadow, punctuated by sunlight, creates a particularly intimate atmosphere.

Children of Sana'a
320 × 430 mm
(12½ × 17 in)
The strong cast shadow created an unusual composition and became a major feature of this painting. Note that even though the children are in deep shadow, there is still detail and luminosity in the figures but within a low range of tones.

▶ *Shadows of the Green Gate*
430 × 635 mm
(17 × 25 in)
The inspiration behind this painting was the decorative pattern of the shadows cast by the gate which itself features less prominently. As the shadows were in this position for only about 30 minutes I returned to the same spot at the same time each day for several afternoons to finish the painting.

Asleep in Istanbul
320 × 430 mm
(12½ × 17 in)
The entire room is in shadow except for a splash of sunlight on the bed. It is the overall cool shadow tone that makes the sunlight appear warm and bright, intensifying the atmosphere of calm and intimacy.

IDEAS
AND
INSPIRATION

Over the centuries artists have explored every conceivable source of subject matter. My inspiration comes from the world around me and is usually based on an instinctive response to seeing something interesting in terms of light and colour. Watercolour is as versatile as any other medium and as the range of subject matter is seemingly endless it is important for you to decide what to concentrate on, while also feeling free to experiment with new ideas and develop your own style and themes.

It takes time to learn how to 'see' a potential subject, however, and this is where an awareness of light can help: the play of light can transform the most mundane of objects or scenes. Here, we will explore a number of ways of deciding what to paint and look at various ideas about composition to help put our ideas into practice.

Gateway to the Blue Mosque
430 × 320 mm (17 × 12½ in)

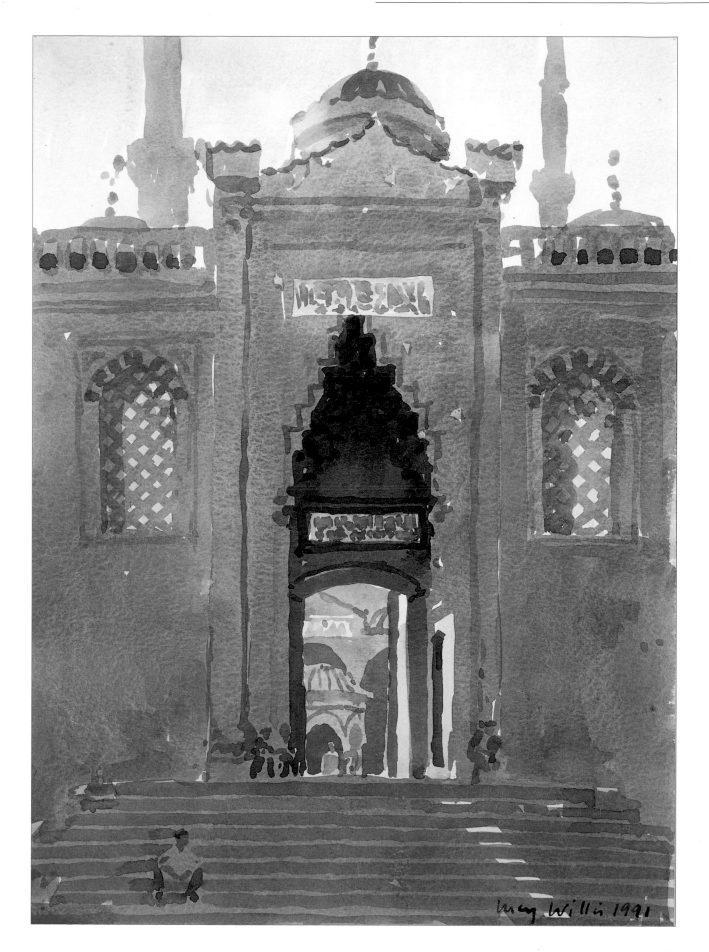

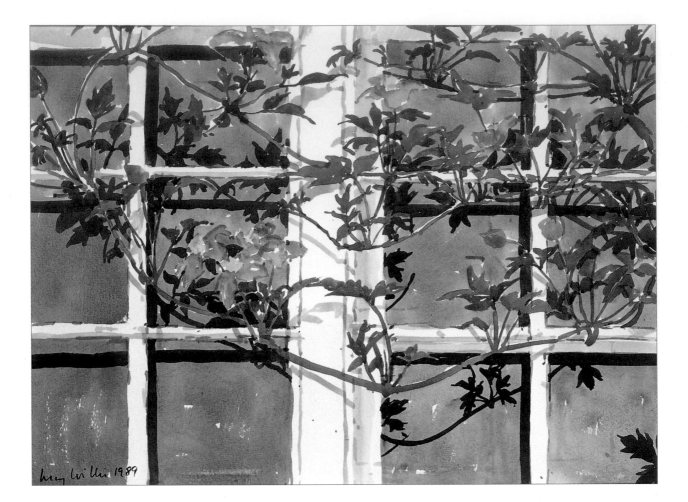

Clematis
320 × 430 mm
(12½ × 17 in)
This is the view I see
each time I walk from
the garden into the
house through the back
door and I had it on my
list of potential subjects
for some time. I painted
it one day when the
clematis was in flower,
creating a rhythmic
pattern with its reflected
silhouette and the white
grid of the window bars.

CHOOSING A SUBJECT

Having a clear idea about what inspires you
helps to avoid the common problem of
searching restlessly for a potential subject,
hoping to stumble on the perfect picture
around the next corner. I try to keep a
stockpile of ideas to draw on, based on things
that have caught my attention and which I
have either made a mental note of or jotted
down in words or sketches for future use.

When deciding on subjects for watercolours
I have four basic approaches. Sometimes I see
a good subject and immediately settle down to
paint it, or I repeatedly notice a potential
subject over weeks or months before
crystallizing the idea and making it into a
painting. On other occasions, I may
deliberately set up an arrangement to create a

composition or I might see something once, remember it, and turn it into a painting later from memory.

KEEPING IT SIMPLE

I am often surprised that beginners in watercolour start by painting landscapes. I spent ages grappling with the medium in the studio before venturing even into the garden. While I can see the attraction of painting landscapes, it can be a mistake to assume that this should offer a 'better' subject than a closer study. Of course, it is a matter of personal preference but try to avoid being too ambitious to begin with and start on a simpler scale if you are unsure of your technique. Painting individual objects or a still life is often easier and once you reach the stage when you feel fully in control of the medium you can start to expand your horizons and take on more complex subjects.

Urn, Hestercombe
320 × 430 mm
(12½ × 17 in)
I visited Hestercombe garden intent on a day's painting but not knowing what I would find. Eventually the urn with its strong reflected light caught my eye and I could see the potential of the sunlit area set against the dark background.

Hababa
430 × 635 mm
(17 × 25 in)
Inspired by the evening
light and reflections,
I worked quickly before
these changed. Back in
the studio I was able
to rekindle the
experience to finish
the painting.

MAINTAINING THE INSPIRATION

Before you start, identify what it is you enjoy
about the subject and try to envisage how you
would like the painting to look when you have
finished. Perhaps jot down some notes, or key
words, in a sketchbook, which may help you to
decide what to include, emphasize, or leave out
as the painting develops. Throughout the
painting try to keep in mind why you decided
to paint it in the first place.

This may also help you to make decisions
about introducing additional elements or
changing the composition. Often pictorial
shortcomings, such as an awkward empty
space or too much bright colour, become
obvious only as you get into your painting or
when you first stand back from it. In this case
you need to make changes or additions
without losing track of your original motive.

Very often, for me the working process for
a picture which started outside continues back
in the studio, but throughout this process I try
to retain the initial idea in my mind's eye.

Early Morning, Sana'a
430 × 320 mm
(17 × 12½ in)
When you are looking for a subject to paint don't be put off by the presence of objects such as cars; you can decide either to include them, or you can leave them out. I enjoy including them sometimes as they reflect the light and colour from their surroundings and add a contemporary note to an otherwise ancient scene.

In the Shadow of the Old Fort, Zanzibar
320 × 430 mm
(12½ × 17 in)
Although it is important to keep to your original idea or inspiration, try to remain flexible. Here, the background building and the big shadow on the left were the initial inspiration, but I included the lady in black half-way through the painting to occupy what was otherwise an uncomfortable space.

I work quickly on the spot, especially when travelling, to establish the essential composition and get down enough information to allow me to finish painting at home, which can then take weeks or even months to complete.

COMPOSITION

Translating your initial inspiration into a balanced and effective composition is one of the challenges of picture-making and although there are no hard-and-fast rules, there are some guidelines that can help. Eventually the process will become instinctive and you should feel free to break the rules and produce some unusual and original compositions of your own.

At art school I was taught not to put the main subject in the middle of a composition, by tutors who believed in a traditional approach, and this is generally sensible advice. Sometimes, however, I may want to paint a study of one particular thing, and the best place for it for maximum impact is in the centre of my sheet of paper. I can then offset this by including elements such as the diagonal shaft of light across the steps in *Gateway to the Blue Mosque* (page 63), which introduces a directional line that helps to break the obvious symmetry.

Don't be afraid of empty spaces within a composition. If it is carefully balanced with a busier area of interest it can be effective for creating emphasis and drama.

VIEWPOINTS

Having decided on your subject you need to be able to select from your general view where the parameters of your composition will be and where on your paper to position the main elements in your painting. A viewfinder can be a definite help; a simple rectangle cut out of a piece of card or just your thumbs and forefingers will do. It is easy to try and include far too much, so select your view carefully but don't worry too much about cropping objects or figures at the edges of your picture as this can sometimes create a far more intimate composition that looks natural and unposed.

There are also practical considerations, such as where you will sit and the angle at which you will view your subject. It could be helpful to ask yourself if you need to adopt a higher

Leftheri Milking
320 × 430 mm
(12½ × 17 in)
My Greek friend milking his cow made a striking composition combining black, white and yellow. The incidental cropped figures of the cow on the left and the dog in the foreground suggest the unposed quality of the picture.

viewpoint, or move further to the left or right
– or get closer or farther away. As I usually
sit to paint in watercolour I often find that
something that looks appealing when I'm
standing, half disappears out of sight when I
sit down.

When planning your position, ask yourself
what you want to emphasize and how you will
achieve this. With landscapes, deciding on the
positioning of your horizon on your sheet of
paper can be problematic. A traditional way to
produce a balanced composition is to observe
the 'rule of thirds', which means dividing your
picture area into thirds, in your mind,
horizontally and vertically, and positioning the
focal point on or near the points where these
cross. Decide whether you want to paint two-
thirds landscape to one-third sky, or vice versa.
More unusual and dramatic paintings can
result from a high horizon with just a sliver of
sky above, or a low horizon where the sky
itself becomes the subject.

*Looking East from
Burrow Mump
560 × 760 mm
(22 × 30 in)*
Although the horizon
conforms to the
traditional division of a
composition into two-
thirds landscape and
one-third sky, this higher
viewpoint and the
diminishing size of the
cows as they recede
into the distance, gives
a more dramatic sense
of space.

WORKING FROM MEMORY

Once you become practised at making visual notes about the world around you, and have developed an understanding about how light, tone and colours work, you will also be able to work from memory. There can be positive advantages in doing so because, as our memory is selective, we are forced to concentrate on the most essential information in a subject and to leave out extraneous or distracting detail. In addition, the more we think about it the more the idea will crystallize in our mind.

Working from memory can be important on the occasions when we want to record something we see, yet are unable to make a sketch or take a photograph.

When looking at something that you intend to paint later from memory it is important to concentrate hard and make mental notes: notice the colours, tones and shapes. Test yourself while you are still in front of the subject by closing your eyes and seeing if you have registered sufficient information for later use; if not, look again at the missing details and test yourself again – it is a bit like learning poetry but you don't have to remember every line.

Pencil sketch of
Night Bathers
205 × 140 mm
(8 × 5½ in)
As it was too dark to sketch this scene on the spot, I memorized it and produced this drawing the next morning, concentrating on the lively interplay of light, dark and mid tones which I had made an intense effort to memorize the night before.

▶ *Night Bathers*
660 × 508 mm
(26 × 20 in)
Using the pencil sketch as an aide-mémoire I aimed to recreate the liveliness of the original scene, working with a suitably restricted palette and concentrating on the pattern of dark figures against the lighter water and the sparkling highlights on its surface.

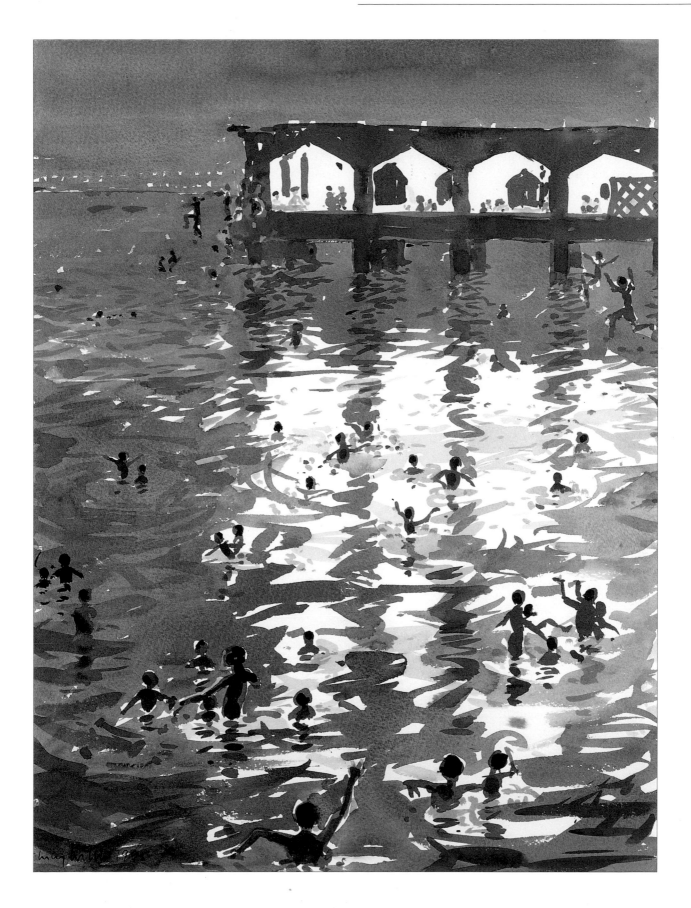

USING THE IMAGINATION

An alternative to working from observation or from your memory of something observed, is to work from the imagination, which is obviously related to both practices. This is a useful skill for any painter but it is also especially relevant for illustrators, who often have to conjour up realistic images without reference to a subject. Often, when I work entirely from my imagination, I find it helpful to combine the use of a graphic medium – charcoal, pen and ink, or crayon – with watercolour, to build up the image, as in *Midsummer Night's Dream*.

Working from the imagination is important not only for creating totally invented images, but also for adding new elements to a painting done from life. To paint convincing pictures you need, as well as basic drawing skills, to have an understanding of how light and shadows work: in which direction shadows fall, according to the light source; whether they are soft or hard-edged; how they are affected by

▲ *Midsummer Night's Dream*
255 × 205 mm
(10 × 8 in)
One of a series of illustrations on the theme of this play, I tried to imagine how a winged figure would appear in a flood of moonlight.

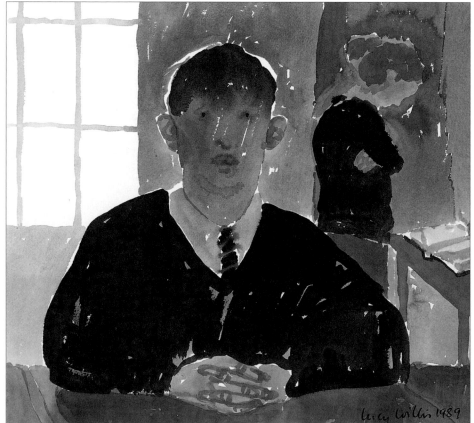

Imaginary Portrait
660 × 510 mm
(26 × 20 in)
I used this imaginary character as a vehicle for exploring an idea about sunlight falling across a figure. This gave me more freedom and scope to be inventive than if I had been working from a sitter.

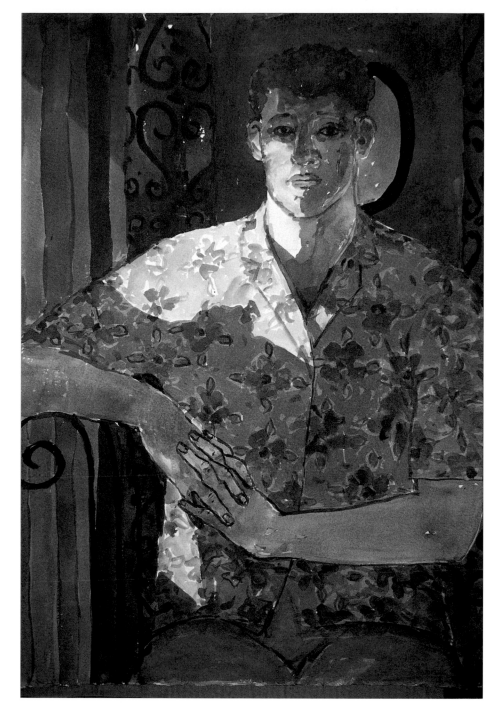

◄ *Boy with Translucent Ears*
255 × 255 mm
(10 × 10 in)
This was painted partly from memory and partly from my imagination. The translucence of ears seen against the light has always delighted me and is the inspiration behind this picture. I added the smaller figure in the background to make the picture a more complete composition.

perspective; how to invent reflected light convincingly; how local colour is affected by light and shade – all of which you will have learnt by working from direct observation.

Working from the imagination gives you the scope to be inventive and can be an intense and entertaining discipline. It can help you to loosen up if you have a tendency to copy slavishly from your subject, and it will encourage you to be selective and experimental.

Painting
Watercolours
Indoors

In the past many artists organized their studios so that they painted by north light, avoiding the distractions of bright sunlight and strong patterns of shadow. Today, however, painters tend to be much more interested in these things, and for me the light itself is often the starting point for an indoor painting such as a still life or an interior.

Indoor subjects are often a more practical alternative to painting out-of-doors: you are not affected by the vagaries of the weather and you have more control over the light and the drying time of the paint. In fact, when you are starting with watercolour, before you go outside to paint, it is a good idea to get lots of practice indoors; the variety of potential subjects is just as wide and the effects of light and shadow are just as exciting and diverse.

In this chapter I will show you a range of indoor subjects painted in different light conditions and point out some of the most important considerations when tackling still lifes and interiors in watercolour.

The Front Door
430 × 320 mm (17 × 12½ in)

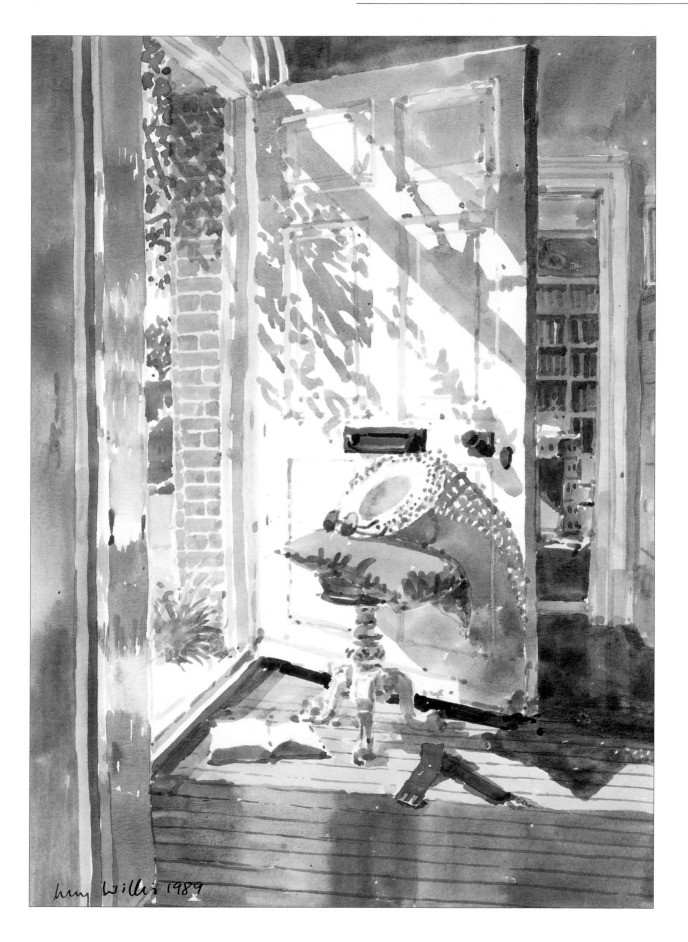

STILL LIFE

The advantage of still-life painting is that you have control over all aspects of your subject: you can select the objects you wish to include; set them up in an arrangement of your choice; control the background and decide on the lighting.

LIGHTING

Even with a simple still life it is important to consider the type of lighting you will use. Keep it simple initially, from a single source, but remember that when painting by natural light it will change to a certain extent during the day and you will either need to work quickly, or return to the painting at the same time each day.

Artificial light is more controllable and constant, but it can make colours appear warmer than they do in daylight. An alternative is to combine daylight with a warm electric light which will suffuse your still-life

subject with cool blues and violets and warm oranges and yellows and set up interesting patterns of hard and soft shadows.

It is important to be aware of the direction of the light too: painting still-life groups *contre-jour* (against the light) will make the objects appear in near-silhouette; tones and colours will be soft and muted. Alternatively, setting up a group of objects near a window, through which sunlight strikes the subject from the side, will give you clearly defined shadows and the modelling of the forms will be stronger. Tonal contrasts will be more marked in bright sunlight than in diffuse or overcast light.

Chocolate Eclair
180 × 255 mm
(7 × 10 in)
Simple studies of individual objects on plain backgrounds can provide the ideal opportunity to study form, colour and light at your own pace.

Mousse Citron
320 × 430 mm
(12½ × 17 in)
On holiday in France, it was a spur-of-the-moment decision to paint this tea-table lit by an electric light directly overhead. This provided a constant source of light which cast strong dark shadows under the plates. The blue napkins complemented the orange colours and this relationship became a central theme.

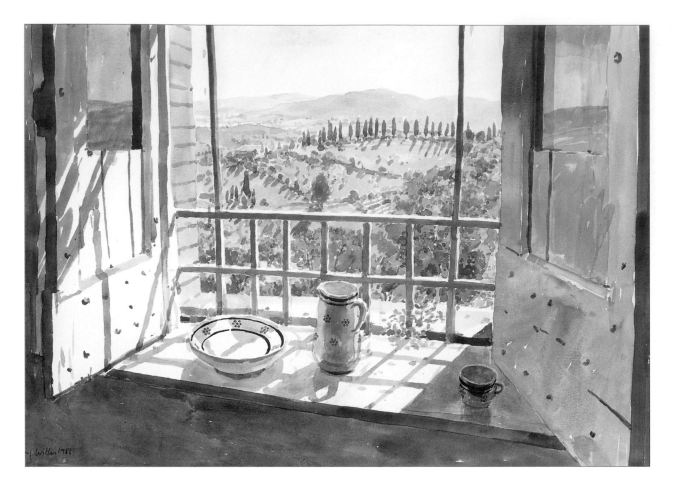

SETTING UP

The choice of objects for a more complex still-life arrangement is vast but, to start with, try not to include too many disparate elements. A personal selection of just a few objects, casually arranged, can have considerable impact in front of a sunlit window, as seen in *View from a Window, Tuscany*. The shadows, too, can become a constructive design element. You might like to include objects with a variety of textures and surfaces and which receive or reflect the light in interesting ways.

Be experimental with your viewpoint; choose one with which you are comfortable and which allows you to concentrate on the aspects of the subject that interest you most. You should consider the spaces in between the objects as well as the objects themselves, as these make equally interesting shapes and form an integral part of the overall design of your painting.

View from a Window, Tuscany
430 × 635 mm
(17 × 25 in)
Although essentially a view out of a window, the introduction of these still-life objects added an intimate note, emphasizing the relationship between the two worlds of interior and exterior.

▶ *Violin on a Patterned Cloth*
430 × 635 mm
(17 × 25 in)
Soft shadows and shiny reflections create a variety of textures in this still life. Note how the ripple of the cloth is described by the undulation of the shadow of the bow.

▲ *Flowers and Mandolin*
430 × 635 mm
(17 × 25 in)
The light from behind these flowers illuminated them, making them glow, and cast interesting shadow shapes which became an important part of this composition.

Hellebores in a Teacup
320 × 430 mm
(12½ × 17 in)
This still life was set up under a north-facing window which enabled me to take my time and study the way the light picked up the intricate patterns and forms. I painted the flowers first, simplified the leaf shapes and finally worked on the surrounding pattern.

PAINTING FLOWERS

Flowers are traditionally a popular choice for still-life subjects, yet they contain many potential difficulties for beginners.

When I paint flowers my aim is to capture the character of the flower by the most economical means. The way to achieve this lies in absolute concentration. Scrutinize the flower intensely. You can simplify the forms to some extent, and make sure that you evaluate the shapes and tones without being diverted by the brilliance of colour. If you can understand the basic form and structure of the flowers, you will be able to describe them without going into too much botanical detail, thereby losing freshness and spontaneity.

As with everything, plenty of observational drawing is a good idea as this will teach you about leaf and petal shapes, how they overlap, and the essential 'character' of flowers. In a similar way to painting portraits, the 'likeness' is achieved by careful attention to proportion and the spaces between features. With flowers there is, however, much more room for minor

inaccuracies. You can always add a leaf, or leave out a flower, if your spacing seems uncertain.

LIGHTING

Lighting will affect the appearance of flowers to an extraordinary degree because of their colour and transparency. When you start it may help to work in diffuse light with a reasonably basic subject. Take a simple pot of flowers, put it near a north-facing window where there is no bright sunlight and make a careful study of the leaf and petal shapes.

In constrast to this quiet, controlled approach look at the different results when the light is strong. The blast of sunlight through the window illuminating the flowers and leaves in *Apple Blossom* created sharp contrasts of tone, strong shadows and highlights, and meant that I had to work rapidly because the position of the sun changed so quickly. This can be an advantage though, as it forces you to simplify more than when the light source is consistent.

Although I prefer to paint flowers in daylight, you may wish to work by artificial light – a spotlight can provide strong, direct

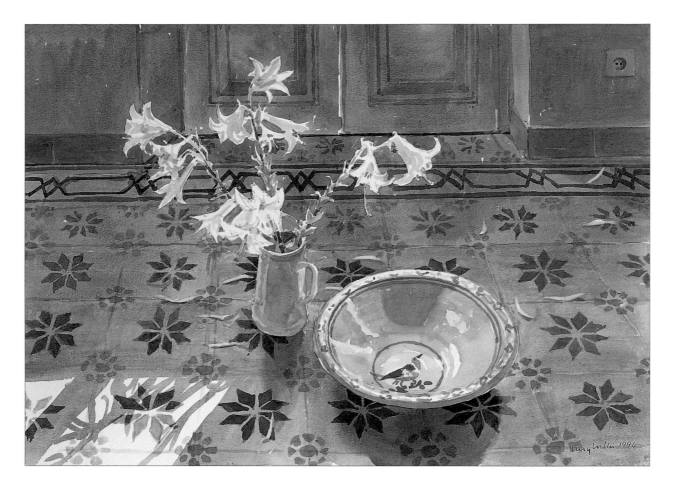

light that will create sharp tonal contrasts. Fluorescent strip lights can give a cooler ambient light with less dramatic shadows, which could be an advantage.

VIEWPOINTS AND BACKGROUNDS

When setting up a floral still life consider your viewpoint and the background; careful thought at this stage can help to overcome some of the problems that can arise. It is a good idea to set light flowers against a dark background since the contrasting tone of the setting helps to define the shapes of the flowers. This may mean laying down the complicated background wash around the shapes of the flowers before establishing them in more detail, so be prepared.

▲ *May Day Lilies*
430 × 635 mm
(17 × 25 in)
I set up this still life on the floor so that I could look down on it and paint the sunlit white lilies against the dark background.

▼ *Apple Blossom*
320 × 430 mm
(12½ × 17 in)
Bright sunlight totally transformed the feel of this simple still life. Note how the shapes of the blossom have been left as light spaces in places.

DEMONSTRATION: HELLEBORES IN A JUG

*F*or this demonstration I chose to paint a single jug of flowers, with simple petal shapes, on a low table covered with a white cloth illuminated by daylight from the unseen window on the right. The light outside, although bright, was diffuse, so the shadows were soft.

A high viewpoint enabled me to look down on my subject. This cut out background detail and allowed me to concentrate on the still life.

▲ STAGE ONE
Using a mixture of Alizarin Crimson and Cerulean Blue I plotted the petal shapes and established the shape of the jug with a creamy yellow wash. I left the centre of the flowers as bare white paper so that I could paint in the yellow stamens later. Where the light shone through some of the leaves I started with a bright green mixture and then introduced some darker greens.

I then added the dark handle of the jug and its shadow, as well as the darkest area of the picture: the space inside the top of the jug. This contributed a sense of form to the objects and a stronger effect of light. Once this was established I began to plot the pattern of the embroidered cloth.

STAGE TWO
Next, I enriched the shadows on the petals with a darker version of the purple used in the earlier stages and enhanced the shadows – and thus the form – of the jug as well as the glazed pattern on it. I also extended the cast shadow with a combination of warm and cool colours.

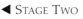

◀ STAGE TWO

▼ STAGE THREE
Finished painting:
Hellebores in a Jug
320 × 430 mm
(12½ × 17 in)
Finally, I concentrated on
the pattern, folds and
wrinkles of the light
background cloth.

Lucy Willis 1992

The Window Seat
430 × 635 mm
(17 × 25 in)
The lightest areas here
are the view outside the
window and the splash
of light on the carpet. By
contrast, the tones of the
rest of the interior are
low-key. Having painted
the main tonal structure
of the composition on
the first day, I added
details such as the
pattern on the carpet, the
crumbling plaster and
the folds in the curtains
the next day when the
light and shadows were
in the same position.

INTERIORS

Interiors encompass a multitude of images
and there are many painting opportunities
to explore in terms of light and its effects
on them.

Although our own home surroundings may
seem uninspiringly familiar at first, they can
provide plenty of convenient painting
material. Many of the interiors in this book
were painted in my own home where the play
of light is an ever-changing source of interest.

If you are considering painting an interior
for the first time, keep the idea simple. Don't
take a whole room, look at it in sections and
be aware of the different light at various times
of the day.

DAYLIGHT AND SUN

An important consideration when painting
interiors in bright sunlight is the speed at
which the sun moves round, as we have

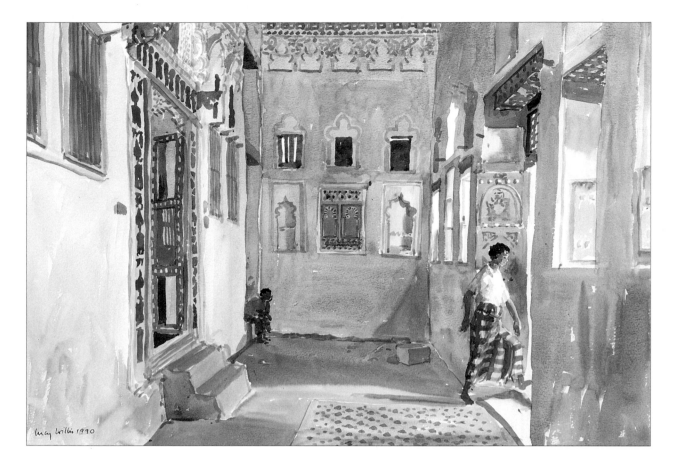

already seen in the chapter on light and shadow. As with outdoor subjects, you need to decide on your viewpoint and composition and establish the shadows or patches of light in the position you want them as quickly as possible. Don't carry on working for too long once the sun has moved round because the change in the shadows and reflected light in your interior will radically alter all the other tones.

In *The Window Seat* I worked quickly to catch the sunlight shining through the window and its pattern on the floor, as well as the reflected light on the wall and carpet covering the seat. In these situations detail is secondary to tonal relationships. Your main concern should be to get down the overall pattern of light and shade, remembering to keep the light outside the window the brightest area of the painting.

Interior, Zabid
430 × 635 mm
(17 × 25 in)
I was fortunate to gain access to this Yemeni building and escape the midday heat while I painted it. The glare of the midday sun filtered through the doors and windows giving a bright feeling to the whole space.

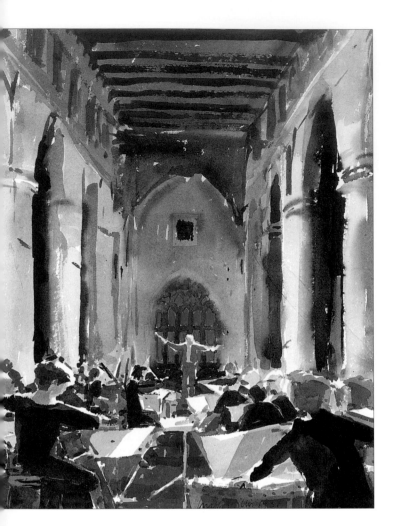

The Overture (detail)
380 × 560 mm
(15 × 22 in)
This painting was done from a tiny pencil sketch made during a concert. The blue of the evening sky, visible through the window behind the figure in the spotlight, and the warm colours of the church, were recreated from memory back in the studio.

▶ *Girl Reading in Bed*
430 × 635 mm
(17 × 25 in)
I painted the lightest areas with tinted washes of Cadmium Yellow to suggest the yellow light thrown by the reading lamp. Note the double shadow of the near bedpost; one in dark grey cast by the daylight from the window, the other, cast by the artificial light, in blue. They are similar in tone but different in colour: the shadow cast by the artificial light is the same mixture as the other one, minus yellow – the yellow of the artificial light is blocked from contributing to the shadow by the bedpost.

ARTIFICIAL LIGHT

Sometimes it can be more interesting to paint interiors that are illuminated by artificial light, or combinations of daylight and artificial light, as in *Girl Reading in Bed* (above opposite) in which the warm pool of light cast by the reading lamp contrasts with the blue daylight, creating a cosy, intimate atmosphere and making this a particularly attractive subject. In contrast, the church interior in *The Overture* is rather more lofty and the tiny figure of the conductor in the spotlight accentuates the height of the building.

More complex patterns of light and shadow are formed by the introduction of more than one source of artificial light, especially when combined with daylight.

You can see in these paintings how electric light is yellow and warmer than the cooler, blue daylight. The combination of the two light sources sets up a subtle interplay of warm and cool colours. Note, too, how shadows cast by the cooler daylight appear warm where they absorb the warm light from the electric light source, and how the shadows cast by electric bulbs appear very blue where they absorb the cool daylight.

Candles create a soft flickering light, which illuminates an interior with a warm glow. In *The Candlelit Dinner* I was attracted by the way the candles transformed an everyday situation into something more interesting.

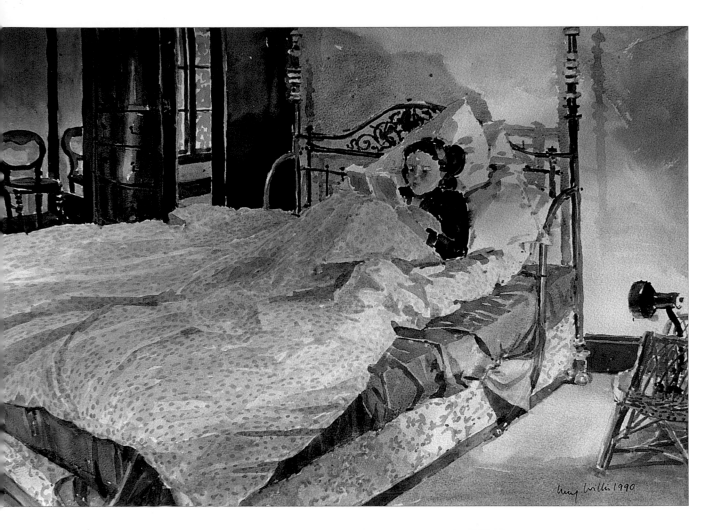

◀ *The Candlelit Dinner*
320 × 430 mm
(12½ × 17 in)
I painted this on the spur of the moment at the end of the meal, concentrating on the play of light across the jumble of objects on the table. I later reworked the figure back in the studio, lifting some colour to increase the feeling of light on the underside of her face. The objects furthest away from the candlelight received the least light and I was careful to keep these tones in a low key.

DEMONSTRATION: HIGHCHAIR

*T*o practise studying and painting the effects of light at different times of day, select a favourite or familiar view, incorporating a window, and notice the changes in tonal relationships as the light conditions alter. As you can see here, the view through the window is lighter than the interior in the morning and early afternoon and then much darker at night when the only source of light is artificial. You will also be able to study how the colour and impression of space and atmosphere are changed.

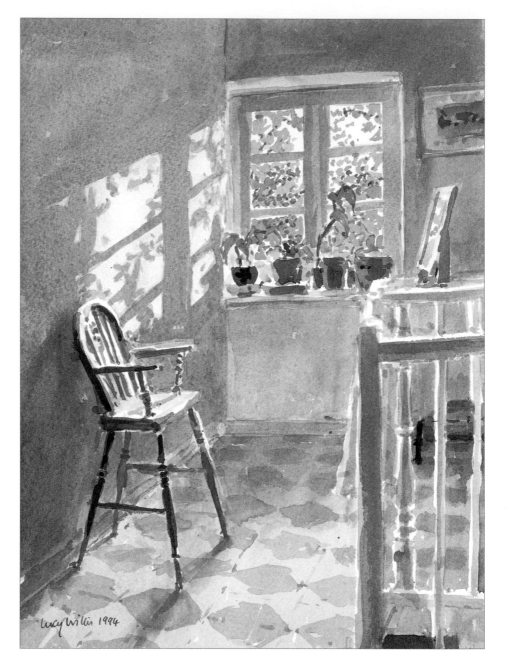

▲ *Highchair, Morning*
430 × 305 mm
(17 × 12 in)
I was attracted to this scene by the pattern of the light on the landing wall; it was painted about a year before the other versions and is the view I see at a particular time every morning. The pattern of light on the wall lasts only a short time before the sun moves round, so I captured it quickly by painting the shadow around it once I had mapped out the general composition.

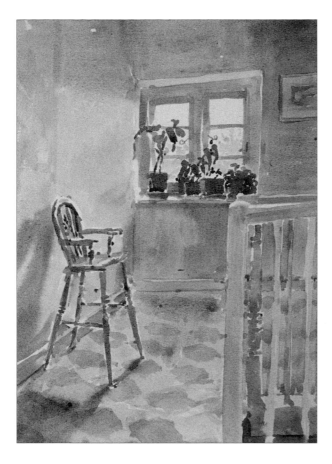

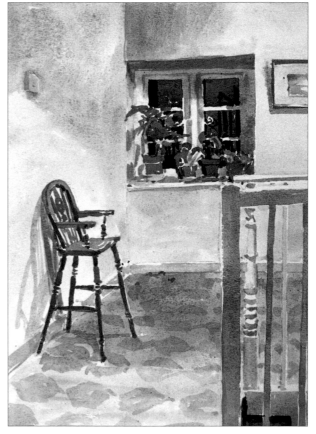

▲ *Highchair, 2pm*
430 × 305 mm
(17 × 12 in)
The sun has moved
round and the shadows
on the wall are now
softer, painted wet-in-
wet. Outside, the
window is lighter than
anything inside. The light
remained constant for
some time. When I had
finished I traced the basic
elements and transferred
this information to the
next sheet of paper to
save working out the
drawing again.

▲ *Highchair, 9pm*
430 × 305 mm
(17 × 12 in)
The only source of light
here is that of the
electric light inside.
Compared with the
morning picture, the
tonal relationships in the
window are reversed and
the chair and banister
are in starker contrast to
the background.

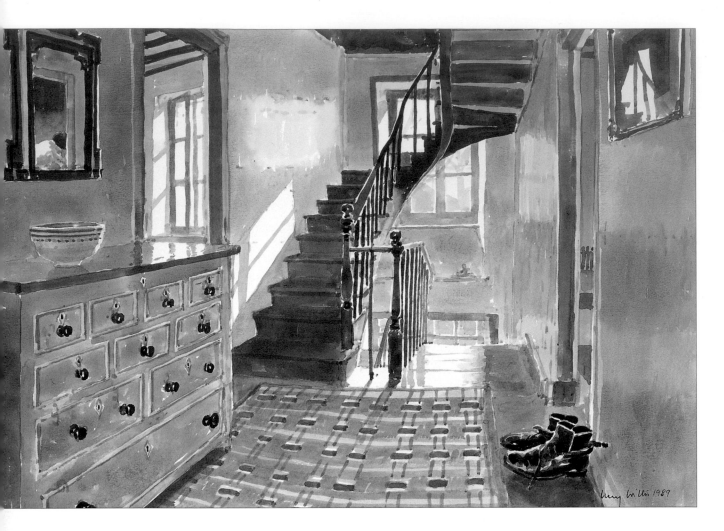

ALTERNATIVE VIEWPOINTS

I sometimes return to make studies of the
same room at different times of day under
different light conditions. It can be useful to
study the light in this way. Additionally, you
can view a room from different positions; look
at the tonal values and colours and note how
the local colours are affected by the light. For
example, *Morning, Le Presbytère* is
illuminated by cool morning light, while *Girl
at a Window* was painted from the other side
of the landing when the late afternoon sun
created a golden glow, hence the difference in
the overall colour temperature.

Morning, Le Presbytère
430 × 635 mm
(17 × 25 in)
The twisting wooden
staircase was the focus
for this painting which
also became a study of
reflections and cool
morning light.

Girl at a Window
430 × 635 mm
(17 × 25 in)
The warm afternoon sun completely changed the atmosphere of this interior, which I painted from the opposite side to my position in *Morning, Le Presbytère*. I also changed the height of my viewpoint by sitting on the stairs, which are still a special feature of the composition. The sun bounced off the right-hand wall and window panes, illuminating the entire space and throwing a reflection onto the left-hand wall and floor.

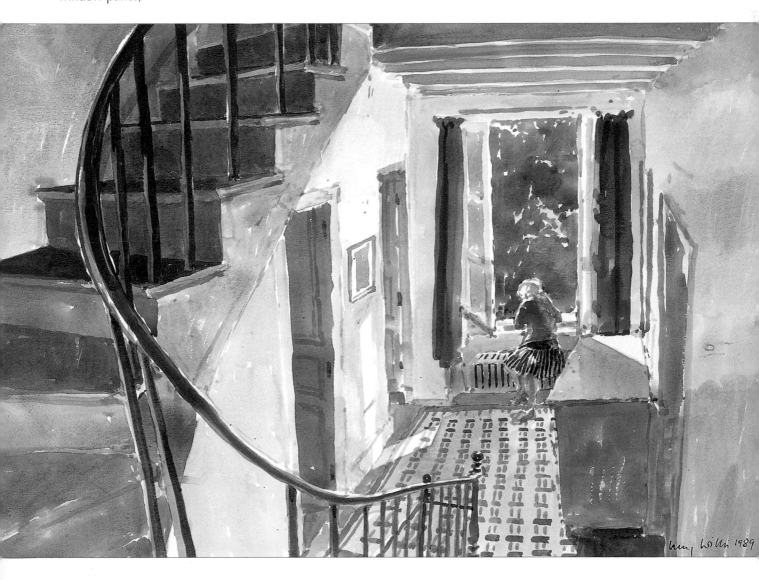

WINDOWS AND DOORWAYS

An open window or doorway has a particular appeal for painters; it not only gives you a 'frame' for the source of light in an interior, it also allows you to include a glimpse of the world outside, which can be inviting for the viewer. The landscape in *View from a Window, Tuscany* on page 78 is nicely contained by the sunlit shutters and windowsill whose relative size give a strong sense of distance to the view outside. Similarly, in *Back Door, Cliff Cottage* it was the view of the sunlit scene glimpsed through the doorway that caught my attention.

Virginia Creeping
610 × 760 mm
(24 × 30 in)
I chose an overcast day to start this watercolour so that the etched glass would show up well against the trees. Although the doors and walls are painted white, they appear much darker than the sky because the light in the interior is so subdued.

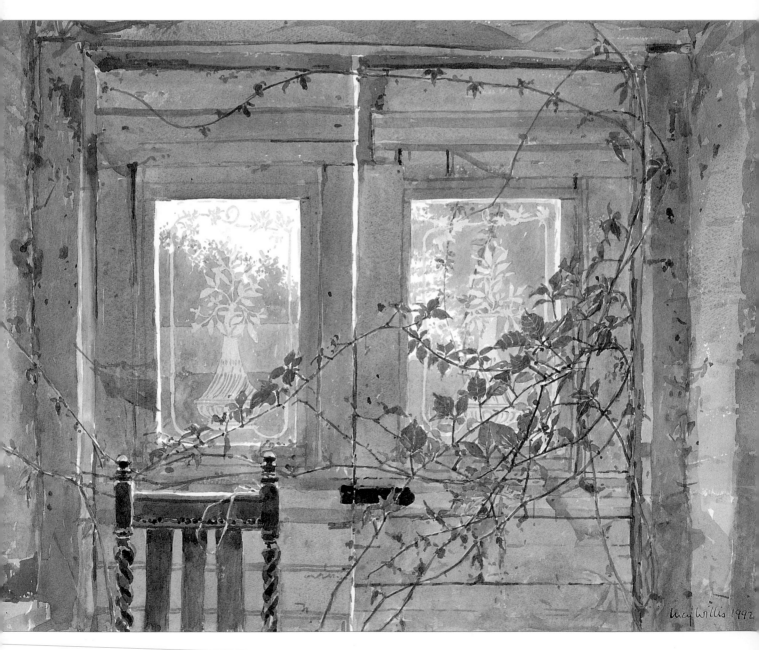

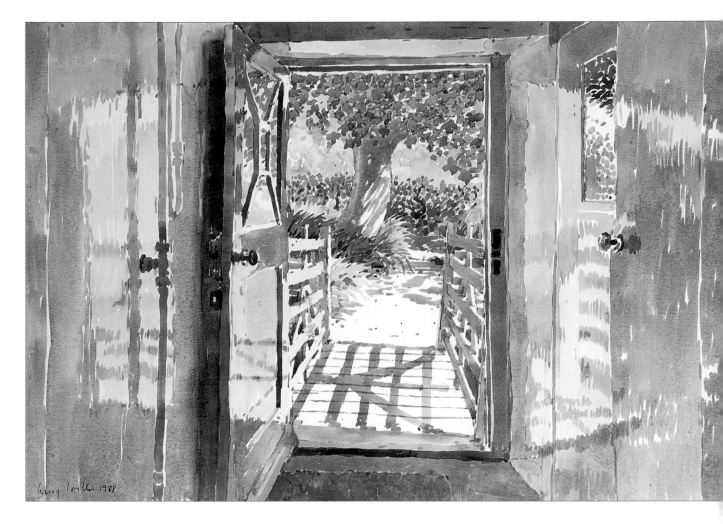

REFLECTIONS

When painting interiors you will notice that
reflective surfaces crop up frequently on
polished furniture, gloss-painted surfaces,
mirrors and picture glass. Often, the light
from windows or open doorways is reflected in
these surfaces; it will help you if you notice
where the reflection is coming from in order
to recreate it convincingly.

Painting reflections in shiny surfaces is a bit
like painting water (see page 104), without the
added difficulty of movement. It is largely a
matter of half-closing your eyes and carefully
analysing the tones and shapes. You also need
to look at the quality of the edges and the
colours in the reflected image.

Back Door, Cliff Cottage
430 × 635 mm
(17 × 25 in)
As the painting
developed the reflections
inside became an
important part of the
composition. The colours
in the glossy white walls
are muted versions of
those outside, where
they are brighter. Note,
too, the reflections in
both the glass of the
open doorway on the left
and on the textured glass
on the right, setting up
an even more complex
interplay of reflections.

PAINTING WATERCOLOURS OUTDOORS

Many of the factors that influence the quality of the light outdoors may seem obvious, such as the time of day, weather conditions or seasonal changes, but the various manifestations are always challenging and often unexpected. While sunshine is endlessly appealing, often equally inspiring paintings can be found in more sombre atmospheric conditions. Here, we will look at some of these different situations and outline various approaches to painting a whole range of outdoor subjects.

Fountain of Clear Water
430 × 320 mm (17 × 12½ in)

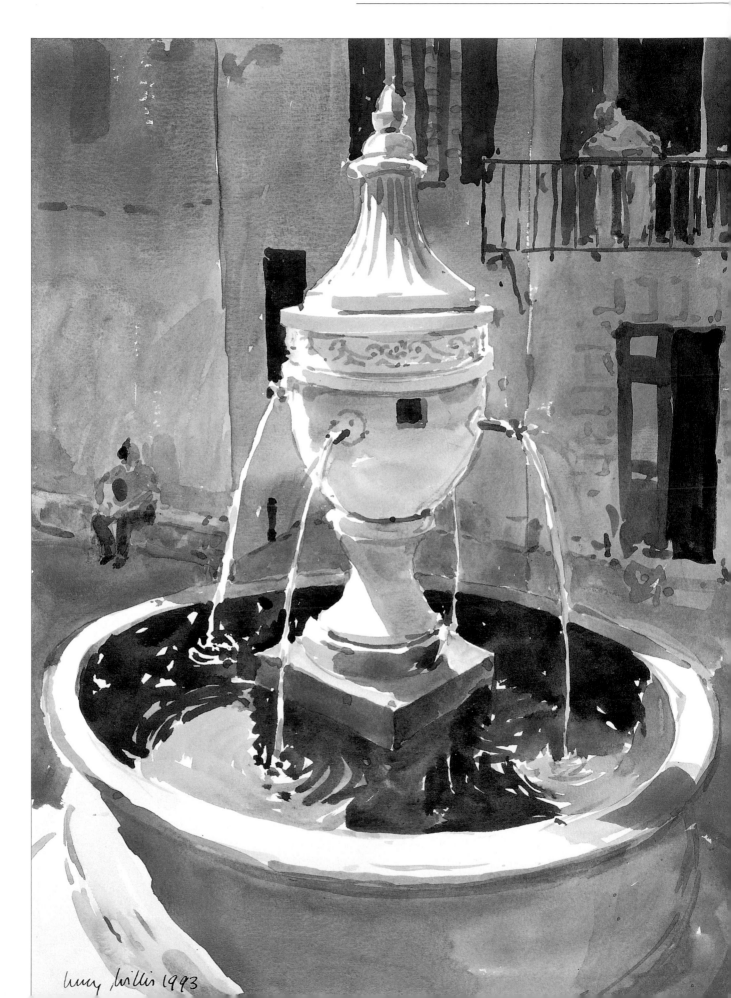

lucy willis 1993

LIGHT CONDITIONS

As the sun moves across the sky the direction and intensity of the light change, affecting the impression of form and atmosphere. So, when planning a painting the timing is all important. You might find that you will see something interesting and earmark it for a watercolour, only to find that when you get the opportunity to paint it, the light has changed and the subject has become disappointingly flat.

TIME OF DAY

It can be a useful and instructive exercise to study and explore the different effects of light by painting the same subject at different times of day, choosing the best point of view according to the light.

◀ *Door in the Lane, Late Morning*
430 × 320 mm
(17 × 12½ in)
I often paint the same subject in different light. This was the most interesting viewpoint at this particular time of day, when the sun was high and the shadows short. Note how the light striking the gatepost is accentuated by its contrast with the dark foliage behind.

▲ *Door in the Lane, Evening*
430 × 320 mm
(17 × 12½ in)
Here, the glow of evening light has warmed the white of the gate pillars, and changed the palm fronds to a warm brown with its bright orange light.

PAINTING CONTRE-JOUR

It helps to be aware of the different effects that the direction of the light can have on your subject. Painting *contre-jour* – looking at your subject against the light – can help to simplify it since it throws much of the subject into partial silhouette. Much of the image will be implied, and detail vague. Painting against the light, particularly in the early morning or at dusk, reduces the amount of colour you can see. But if something is translucent, like foliage for example, the sun intensifies the colour by shining through the leaves, an effect that I especially enjoy.

In order to shade your eyes from the glare of the sun and enable you to see colour and tone more easily it may help to wear a wide-brimmed hat to work *contre-jour*.

Dog with a Stick and Young Chestnut
320 × 430 mm
(12½ × 17 in)
I painted this scene on a frosty morning looking into the sun. Note the *contre-jour* effect of the bright rims of light around the dog's tail against the dark shadow of the background wall.

MIDDAY LIGHT

At midday the sun beats down from more directly overhead, depending on the season and how near the equator you are. In southern India, for example, the midday sun offers very little shadow; those that are cast appear more or less directly under objects.

SIDE LIGHT

When the light falls on the subject from one side it throws the other side into shade and creates a strong cast shadow. In *Provençal Church* the shadow is cast across the subject from the sunlight striking from the left-hand side, casting shadows to the right and giving volume to the buildings. As you can see here, side lighting can create strongly contrasting patterns of tone.

Provençal Church
430 × 635 mm
(17 × 25 in)
Light striking the subject from the left casts shadows to the right of objects and gives a light edge to the buildings in this view.

FRONT LIGHT

Subjects observed with the light striking from directly above and behind you often appear flat but they can be interesting in certain circumstances. The sun will cast shadows leading away from the objects in front of you, and there will be less shadow to help define the form of objects. However, if you position yourself so that the shadows cast by objects behind you become part of the foreground of your composition, the resulting pattern of light and dark shapes can add interest to your painting. Sometimes, therefore, it is an advantage to paint on a cloudy, overcast day when there is no sun, the light is all pervading and shadows soft.

Ruth's Garden
430 × 635 mm
(17 × 25 in)
Here I sat in dappled shade with the light shining from behind and over my left shoulder, casting the shadow of the garden chair into the left foreground and creating the dappled shadow of the fig tree, also out of the picture.

WEATHER CONDITIONS

The weather, naturally, will affect the quality of the light, whatever the time of day or season, and although the vibrant colour combinations of bright sunlight provide inspiring material for the painter, inclement weather conditions can be just as beautiful and give a landscape a different kind of magic and atmosphere.

RAIN

Painting in the rain naturally presents practical difficulties and I do not recommend deliberately going outside to paint watercolours in these conditions, without shelter, as your picture will dissolve in the raindrops. However, rain does create a particular atmosphere and is accompanied by overcast, flat light, few shadows and muted colours. So take advantage of these factors.

BLUSTERY DAYS

Dark skies on stormy, blustery days with fleeting clouds, which cast shadows on the ground and provide glimpses of sunlight in between, can be exciting to paint, if unpredictable. Again, do not be put off by such conditions as interesting effects of light can often be seen if you are prepared to brave the elements.

SNOW SCENES

Painting the snow in watercolour is particularly gratifying as the bare white paper can play a really positive role in describing its whiteness. Furthermore, the way the white of the snow reflects light and receives shadows is fascinating, and makes a welcome change from the challenge of painting the greens of summer landscapes. Sunlit snow scenes, especially, receive lovely purpley-blue shadows, depending on the strength of the sunlight and the colour reflected from the sky. On overcast days, as well as on sunny ones,

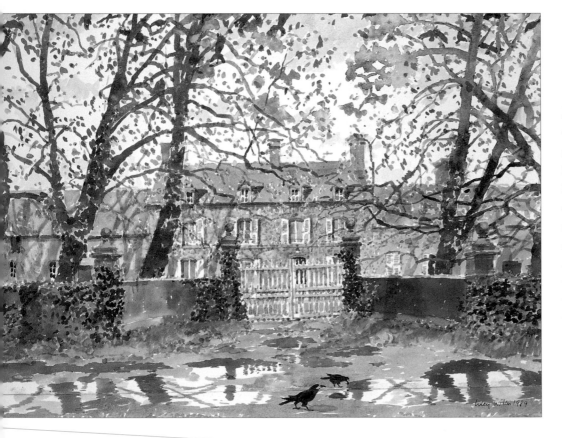

French Rookery
455 × 635 mm
(18 × 25 in)
I was attracted by the house and its sombre colours, but when it started to rain things changed unexpectedly. I added the puddles in the foreground back at home from memory after taping a one-inch extension to my sheet of paper and did my best to incorporate the splodges in the trees where the raindrops had splashed.

High Ham Church
380 × 560 mm
(15 × 22 in)
Here the low winter sun cast elongated shadows of the trees behind me, making a bluey-grey pattern on the bright snow which I left as bare white paper.

◄ *Yellow House*
430 × 635 mm
(17 × 25 in)
Atmospheric haze also causes features in the landscape to appear bluer and paler the further they recede into the distance. Try to look for these effects, known as aerial perspective, as they help to create the impression of space and distance in your landscape paintings.

the tone of the sky is often darker than that of the snow-covered land – an interesting reversal of the usual order. Buildings and trees can be dark and dramatic, suggesting a limited palette of subtle colours, plus the white of the paper for the snow. Look for patterns of light and dark and notice how the dark shapes are intensified by the white of the snow.

MIST

Some lovely atmospheric effects occur on misty mornings. The water vapour held in the air acts like a filter, reducing contrasts in colour and tone and flattening out forms, especially in the distance. You can see this effect in *Yellow House* in which the tonal value of the colours decreases the further away they are. As the humidity changes, the effects created can be most inspiring.

SKIES AND CLOUDS

As well as the sun, the sky is the main source of light in nature and this light determines the overall atmosphere and mood of your landscape. It is an elusive, ever-changing but vital element and can be difficult to capture; nevertheless, it should be treated as an integral part of your composition. Don't make the mistake of painting the sky in a different 'language' from the rest of your picture. Inexperienced painters sometimes find it easy to loosen up their handling of watercolour when it comes to painting the sky, but then tighten up again when they paint the rest of the landscape, with rather disjointed results.

SKIES

1 Mackerel skies create a strong sense of perspective as the cloud shapes become smaller and closer together in the distance.

2 Here there is a combination of all sorts of different effects, including clear sky glimpsed through broken cloud and vertical shafts of sunlight.

3 It is important not to flood the entire sky area with water or paint when you need to retain crispness around the edges of clouds, especially when the light creates white halos.

4 I often work wet-in-wet when painting skies, which is ideal for creating the swirling effects of moving water vapour.

▲ 1

▲ 3

▼ 2

▼ 4

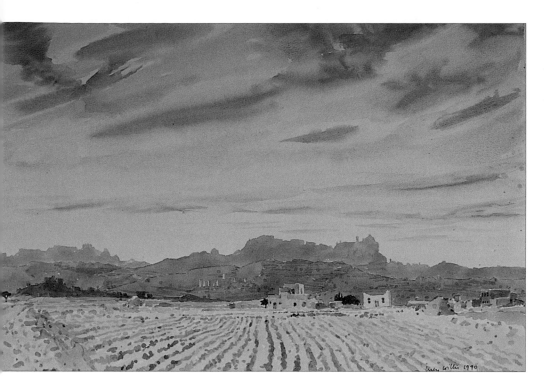

Plateau Landscape, Yemen
430 × 635 mm
(17 × 25 in)
The clouds nearest to us are larger and more strongly coloured than those which become smaller and lighter in tone towards the horizon. As the horizon line is low more emphasis is placed on the sky, increasing the illusion of space.

PLANNING AND PRACTICE

Planning is essential when painting the sky. Analyse and mix up the colours you know you will need so that you can work boldly and directly. Get your tones right, load your brush with plenty of paint and work loosely so that you capture the freshness and fluidity of cloud effects. There is no point in trying to stick to exactly what you see since the shapes change so quickly. Often, working from memory can be more successful than trying to catch a moving sky. So look hard before you paint it.

Practise assessing the colour, tone, shape and volumes of clouds by making lots of studies on separate sheets of paper. Watch the changing patterns and look out for the cooling of colours towards the horizon. Look, too, for the halo effect of the sunlight around the edges of clouds where it illuminates the water vapour of which the cloud is made; leave the white paper for this and pay careful attention to the edges of clouds so that they blend naturally into the surrounding atmosphere. Very often you will see a whole range of different edges, from soft and blurred to crisp and defined, all in one sky. Remember, too, that clouds are often voluminous forms and

should be treated as any other rounded shape. Look for shadows in the clouds and reflected light giving a warm tinge. Yellows, browns and mauves often crop up in a cloudy sky.

The laws of perspective also apply, clouds can be huge directly overhead, at the top of your picture, but will appear much smaller, sometimes flatter and closer together, towards the horizon as they recede into the distance. Additionally, the sky directly overhead is clearer than at the horizon where atmospheric effects cast a thin veil over the landscape and sky, making them appear greyer and less distinct at this meeting point.

For cloudless skies, note the transition of colour from a warm Cobalt Blue at the top, through cool Cerulean, to near-white towards the horizon.

103

WATER AND REFLECTIONS

As it is transparent and does not always have a distinct colour of its own, water depends on the nature of the light for its appearance, and in particular the reflections in it. In essence, painting water is a matter of studying and understanding reflections, which takes lots of practice and close observation.

The fact that water is very often a moving subject makes it difficult to see what exactly is going on – even the calmest water can be disturbed by ripples which distort reflections. The key is to study the patterns, distil what you see and simplify the surface of the water into the major shapes of light and dark. In still water, reflections appear almost as an exact mirror-image; reflections of light objects may appear slightly darker, so half-close your eyes or compare the tones. As with painting skies, you must constantly judge the relative tonal

▲ *Bathing Pool, Yemen*
320 × 430 mm
(12½ × 17 in)
Note how the water consists of four tones: the bare white paper indicating the lightest highlights; the light blue reflection of the sky; the mid-tone green of the general reflections and the darker tone of the deeper green.

*The Washing Place,
Tourrette*
430 × 320 mm
(17 × 12½ in)
Here, the leaves floating
on the surface of the
water define its
horizontal plane, while
the reflections of the
buildings in the water
appear to lie beneath it.
The straight lines of the
reflected house are
broken, suggesting the
slight ripples in the
water. Note how the cast
shadows on the
stonework and the
reflections in the water
describe all sorts of
different planes, angles
and depths.

◀ *The Jetty*
430 × 635 mm
(17 × 25 in)
The lighter parts of the
reflections of the jetty
show the true colour
of the yellow-green
water. The reflection of
the sky appears silvery
white and is suggested
by the broken washes of
pale blue.

values both between the water, sky and land,
and within the different sections of the water.
Dark reflections in undulating water tend to
have sharp, clear edges and a simple series of
spontaneous but carefully shaped brush
strokes can express this.

FOLIAGE AND TREES

Painting outside, especially in the northern hemisphere, usually means coping with foliage, which is one of the most challenging aspects of painting in watercolour. Garden scenes provide an excellent opportunity to study the play of light on trees, foliage and flowers in a reasonably close-up setting. When faced with a complex mass of foliage look for basic shapes and patterns by half-closing your eyes to help eliminate confusing detail. Get your general tones sorted out early on, and don't underestimate how dark the foliage can become in shadow.

You must make crucial decisions about whether some of the foliage is close enough for you to specify individual leaf shapes, or whether you can begin to generalize and

Morning on the Douro
380 × 560 mm
(15 × 22 in)
Here the foreground leaves of the bushes have been painted as specific shapes while in the middle distance they have been flattened to general washes with broken edges; in the distance all detail has become lost in the misty haze.

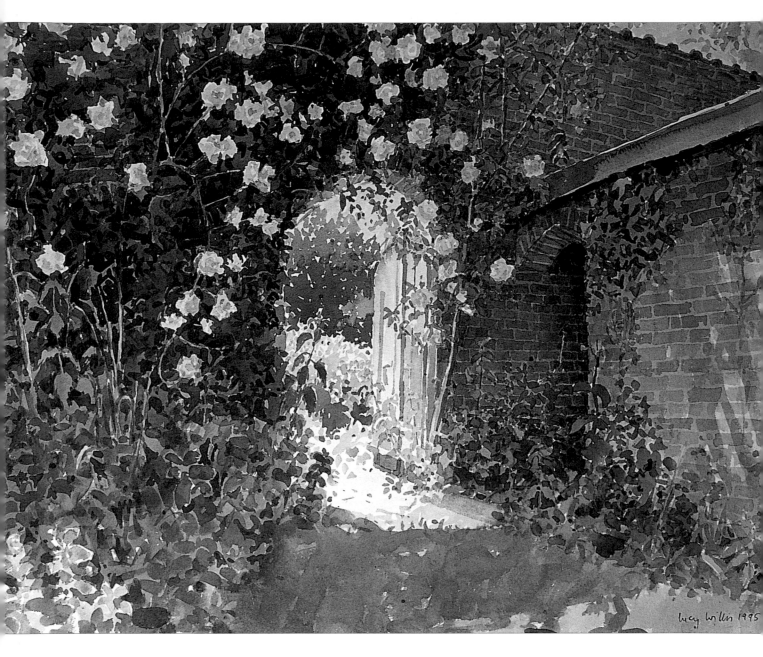

suggest mid-distant foliage by simply defining the outer edges of larger massed shapes; far distant trees and shrubs can be flattened into single flat washes, or two-tone shapes.

You need a light touch when painting foliage in order to get the filigree effect of light shining on, and through, leaves. Your paintings can begin to look a bit 'dotty' if you're not careful, but as long as you paint what you actually see with brush strokes in keeping with the rest of the picture, you should be able to capture this effect successfully. It is also important to vary the colours and tones of your greens sufficiently.

White Roses
760 × 915 mm
(30 × 36 in)
The stinging nettles, foreground leaves and tall grasses on the left have been rendered as specific shapes while the foliage and grasses in the middle distance have been simplified. Unpainted flecks of white paper suggest the sparkling effects of the

light on the leaves. I used a wide variety of greens broadly divided into cool darks and warmer light greens in the sunshine. The greens in the shadowy areas of foliage comprise different mixtures of Sap Green, Cerulean or Prussian Blue and Winsor Violet, with tiny amounts of Cadmium Red to dull them a little in places.

107

INTIMATE GARDEN SCENES

The play of light can also turn forgotten corners of the garden, or overgrown areas, into attractive painting subjects, for example *Compost Heaps* – a mass of different greens and varied leaf patterns.

The more close-up view of the *Irises*, where the sunlight bleached out their colour in places, was also an enticing subject to paint. The bright sunlight and the darker shadowy background made it possible to define their shapes by contrast. There is still a certain amount of detail in the shadows, but it is low in tone and does not distract from the foreground. The leaves were brightly lit and individually painted, shape by shape, changing the colour according to whether the sun was shining through or onto the leaf.

Compost Heaps
510 × 685 mm
(20 × 27 in)
The play of light attracted me to this favourite corner of my garden. Halfway through this painting I placed the rugs on the ground to relieve the dominance of the greens, and to provide a surface to receive the dappled shadow of the tree.

▶ *Irises*
320 × 430 mm
(12½ × 17 in)
With close-up subjects you cannot afford to generalize too much and you must observe the shapes carefully.

Cauliflower (detail)
380 × 560 mm
(15 × 22 in)
Note the range of greens,
from the pale turquoise-
green where the surfaces
of the leaves receive the
light, to the very bright,
warm green suggesting
the light shining through
the leaves.

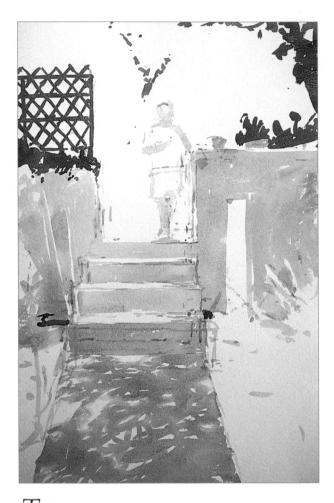

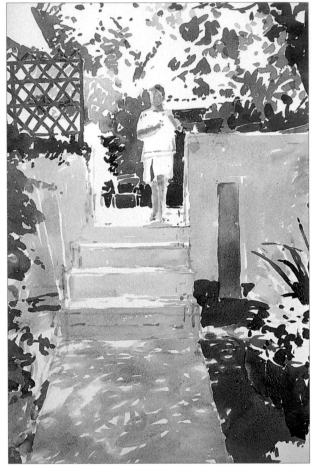

*T*o achieve the **impression of this sunlit garden I translated its complex shapes, textures and mass of detail into simplified patterns and tones. I was intrigued by the combination of the dappled shade and the path's surface design and I also liked the way the sun bounced off the ground at the top of the steps, illuminating my daughter's legs, arms and face.**

▲ STAGE ONE

To start, I made a few skeleton marks with a pale blue colour and began plotting the position of the path, steps and figure in warmer flesh tones to get the main compositional elements in place. Piecing the picture together like a jigsaw, I washed in the foreground dappled shadow and introduced a little yellow where the colours warmed slightly. I was careful to leave the tops of the steps white and I dampened some of the spots of dappled light on the path to soften their edges. As this dried I started to plot the position of the dark tree, plants and trellis at the top using Sap Green and varying amounts of Winsor Violet and Cerulean Blue.

▲ STAGE TWO

When the path was sufficiently dry I was able to butt the dark ground colour up against it. I worked round the shape of the figure with more greens then built up the darks in the foreground pots and foliage.

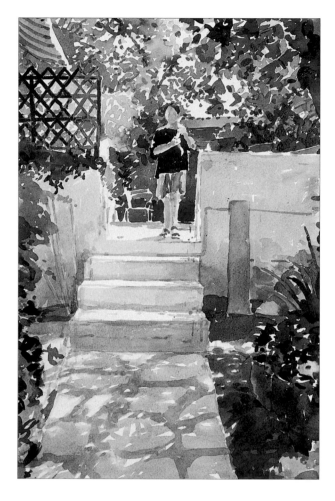

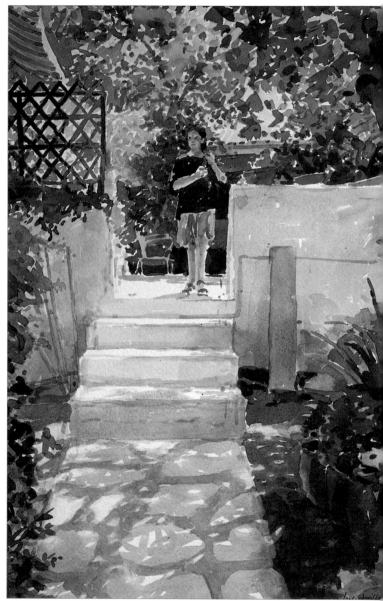

▲ STAGE THREE

I gradually built up the mass of foliage using a wide variety of colours and tones of green. I painted my daughter's T-shirt with a mixture of Prussian Blue, Winsor Violet and Ivory Black and at the same time introduced this colour into the darkest areas of the plants. The cement pattern of the path interweaved with the pattern of the shadows.

▲ STAGE FOUR

Finished painting:
Garden Steps
635 × 445 mm
(25 × 17½ in)
I decided to leave my earlier marks, plotting the position of the steps. Looking at the painting from a distance I felt that the right-hand side of the path needed to be a little wider at the front to increase the perspective, so I lifted the dark tone of the ground and redefined its edge.

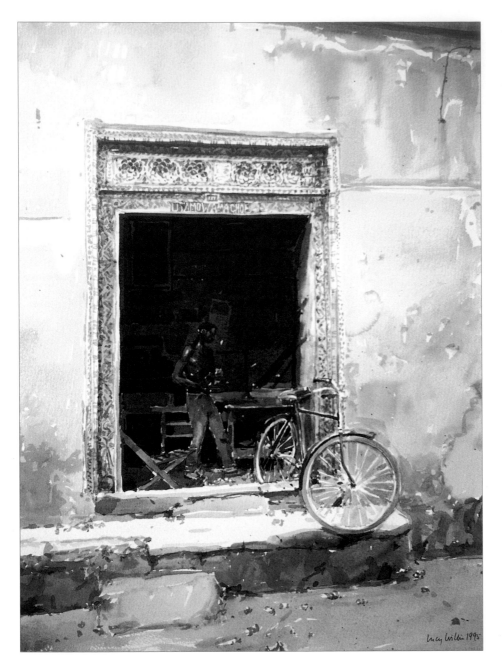

Dark Interior, Zanzibar
760 × 610 mm
(30 × 24 in)
Although this was
painted on a dull day
when there were no
strong shadows, the
tonal contrast between
the dark interior, seen
through the doorway,
and the lighter exterior
wall, made a powerful
image. The crumbling
texture of the plaster
wall was achieved by
applying light broken
washes wet-in-wet.

ARCHITECTURAL SUBJECTS

Towns and cities can provide a wealth of excellent subject matter, often with striking patterns of light and shade which I find especially attractive. When working on the spot in such places, try not to be intimidated by the inevitable groups of people who may come to look at your work. Although it can sometimes pose a problem for me when I am painting abroad, I usually welcome the chance to get to know local people who come to see what I am doing. Spending an hour or two surrounded by the inhabitants of the scene I am painting gives an added insight into the life of the place.

In towns and cities different times of day create different atmospheres, from bright midday light and intense heat to dusk, when the warm colours of electric lights inside buildings become much more orangey-yellow.

Where to position yourself can be a challenge because your viewpoint is important

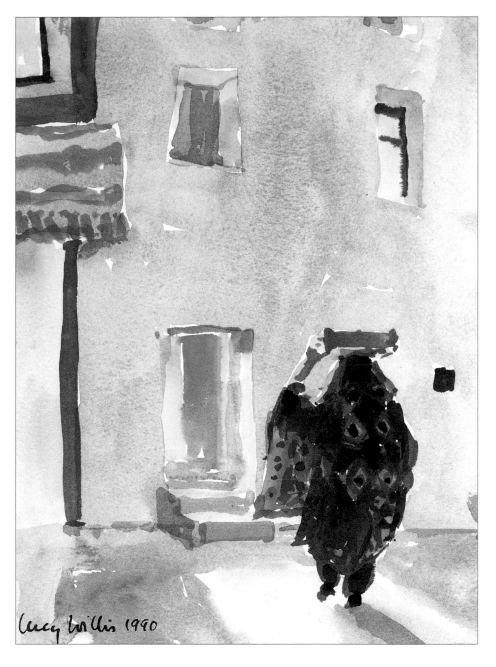

Leaving the House at Dusk
255 × 155 mm
(10 × 6 in)
I liked the contrast between the warm electric light and the cool twilight outside in this scene, so when I got home I translated the coloured pencil sketch I had made from memory into this watercolour, incorporating a veiled figure from another sketchbook drawing. Her dark shape adds a little more substance and interest to the initial observation.

and in some streets you cannot get far enough back to see as much of the scene as you may want to. If you are too close, the perspective of the buildings may be so steep that the distortions will be very difficult to cope with.

Achieving parallel vertical lines can be another problem. This took me a long time to get under control. If you work with your paper flat on your knee, your parallel lines may start to diverge at the top of your paper, simply because of the angle at which you view your painting surface. To overcome this problem, map in your vertical lines with your

board and paper propped upright on your knee. Additionally, you can measure your vertical lines from the sides of your paper with your brush handle, to make sure that this distance is consistent from top to bottom. In reality the perspective lines of buildings will converge towards the top of your paper if you are at ground level and looking up, so it is all the more important not to err in the other direction.

PERSPECTIVE

A working knowledge of basic perspective is important for drawing and painting buildings. Just as important is an understanding of the perspective of shadows. As we saw when discussing *Oxford Afternoon* on page 59, the lines of buildings and their shadows must conform to the same vanishing point.

To make things less complicated for yourself, think of buildings as basic geometric shapes such as cubes and cylinders. Establish their underlying structures, perspective and positions in space before worrying about the details. Remember, where the sides of buildings are visible the horizontal lines of walls and roofs converge to vanishing points on the horizon, often outside the picture.

Depending on where you position yourself, there may be one, two or several vanishing

Houses Overlooking the Sea, Syros
430 × 635 mm
(17 × 25 in)
Here, the lines of the various architectural details on the facades converge to a vanishing point at the right of the picture, except for the building on the left which is positioned at a slightly different angle.

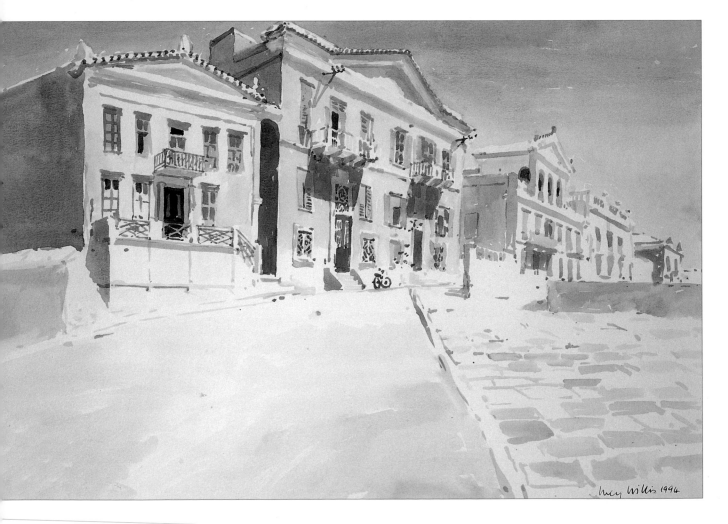

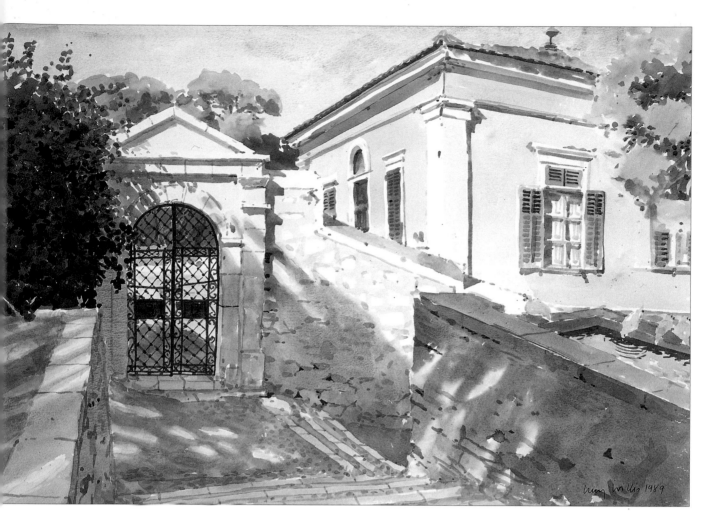

An Empty House
430 × 635 mm
(17 × 25 in)
Two-point perspective is at work here. In such cases you have to imagine these vanishing points, which are outside the picture area, and estimate the angles by eye. Each different plane in the foreground receives the shadows at a different angle, making a complex interplay of surfaces and shadows.

points in one picture, as in *An Empty House*. Understanding vanishing points gives you a method for checking each receding line in your picture, ensuring that your drawing is accurate enough. Train your eye to judge these angles and distances by regular drawing practice, so that when it comes to painting you get the angles right instinctively.

You may also like to check your perspective back in the studio if something looks wrong and you can't work out why. Place your watercolour onto a wooden table top and pin a long piece of string to your vanishing point. This may be within your paper or outside it on the table, depending on your viewpoint. Overlay the string on top of each line of perspective in your picture in turn. I sometimes do this when the perspective is particularly complicated, for example when painting receding rows of doors and windows at different angles.

FIGURES
AND
PORTRAITS

Painting the human figure in watercolour is one of the most challenging disciplines. But if you can learn to see it simply as a set of shapes, tones and colours, and look at the play of light across it, you will soon acquire the key to describing the human figure convincingly.

All the skills discussed so far are vital when it comes to painting figures and portraits: keen observation, simplification, speed if you are painting moving figures, confidence and decisiveness. Here, we will look at how light helps to define the human form and at different ways of painting the figure, from quick watercolour sketches to more involved portrait studies.

Nutmeg Lady in Blue
430 × 320 mm (17 × 12½ in)

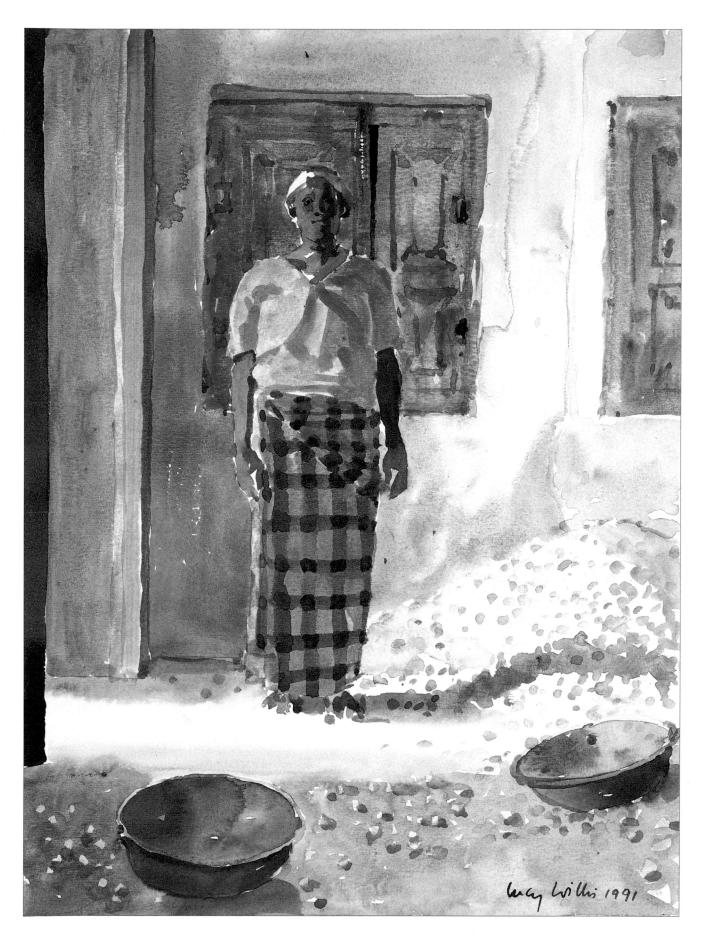

QUICK FIGURE STUDIES

Painting the human figure can be approached in the same way as any other object and is largely a matter of learning to see and simplify the subject into areas of dark, mid and light tones. You may find it helpful to start with flat silhouettes to get a feel for the shapes and gestures of the body, before adding shadows to give a sense of form. Don't be distracted by individual features, especially on the face; ignore these and look at the subject as a series of interconnected tonal masses.

In addition to lots of drawing practise, there is nothing more valuable for painting the figure than the discipline of making quick, ten-minute studies which force you to leave out extraneous detail and concentrate on the overall rhythms of the body, whether in action or repose, in order to capture the essential gesture of the pose.

Once you have mastered the quick study indoors, you will be more confident about capturing the poses and actions of figures outside, as in the studies of the figures on the beach (below opposite). Note how a series of loose marks can suggest the angles and directions of the body and imply a lifelike stance.

Carry your sketchbook with you everywhere and make sketches of people in public places and where you can sketch them without being noticed. Aim to capture the gestures and simple shapes of your subject and pay attention to how the movement of clothing affects the shapes of a figure in action. With regular practise you will become confident about including figures in your paintings. This is so important because very often a competent painting is ruined by a poor rendition of a figure. Similarly, a tightly painted or overworked figure can spoil a loosely painted watercolour, catching the eye and creating a distraction. So try to paint figures in the same mode as the rest of the picture.

Standing Nude with a Blue Ribbon
255 × 125 mm
(10 × 5 in)
A good example of how placing the figure in strong light helps to simplify the tones. Note how the brightly lit side of the figure is left as a white space, which is defined by the mid-tone wash of the background and dark tone of the rest of the figure's shape.

Ironing
305 × 380 mm
(12 × 15 in)
When painting a clothed figure, look for broad areas of light and dark. Notice how just a hint of shadow on the floor anchors the figure to the ground and accentuates the feeling of light.

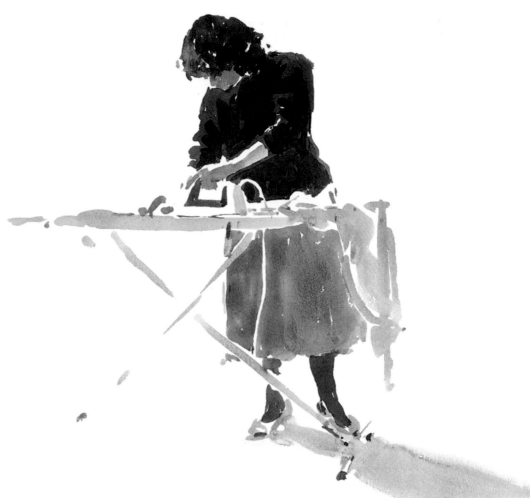

▼ *On the Rocks*
255 × 305 mm
(10 × 12 in)
I had to work quickly to capture these figures sitting on the beach in bright, sparkling sunlight. Notice especially how I have simplified their forms into basic tonal shapes to describe their arms, heads, hair, etc.

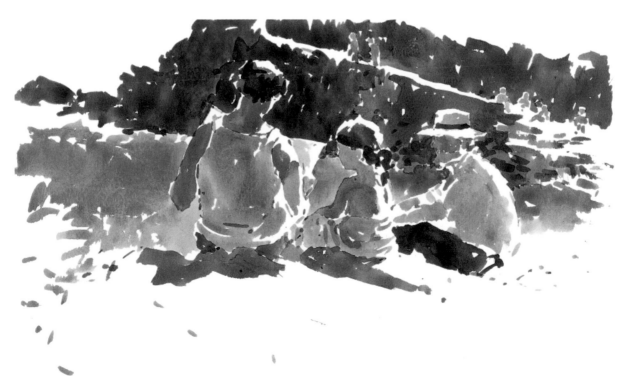

FIGURES IN SITUATIONS

The inclusion of figures in a setting offers many advantages, apart from the more obvious narrative element: their size in relation to the surroundings lends a sense of scale to a composition, or they can become important focal points. A human presence can also bring a landscape, a street scene or an interior to life.

So when you are introducing figures into a painting try to capture their general attitudes and gestures, and the way the light affects their forms. It is vital when including figures after you have started a composition to look at how the light affects and defines their shapes, and how their shadows fall, to ensure their harmonious integration into a painting.

You can also use the colours of clothing to complement or harmonize with the colours of your composition, as I have done in *Palace, Madurai* (below opposite). I sometimes do this deliberately, especially if I feel that a painting needs an extra splash of a particular colour. But beware of creating jarring juxtapositions.

For adding figures to your paintings back at home it is useful to have a sketchbook full of different figure studies which you can refer to for reference. It also helps to think ahead: leave white spaces of roughly the right shape and size into which you can work your sketchbook or invented figures later. This will look more natural than trying to superimpose a figure onto your painted surface.

▲ *Looking at Watercolours*
255 × 180 mm
(10 × 7 in)
This picture was painted from a photograph of a group of Omani men watching me paint (left). In order to retain a spontaneous feel it was important not to copy the figures in any great detail. I left out my own figure and instead painted the men looking at a watercolour painting on the ground.

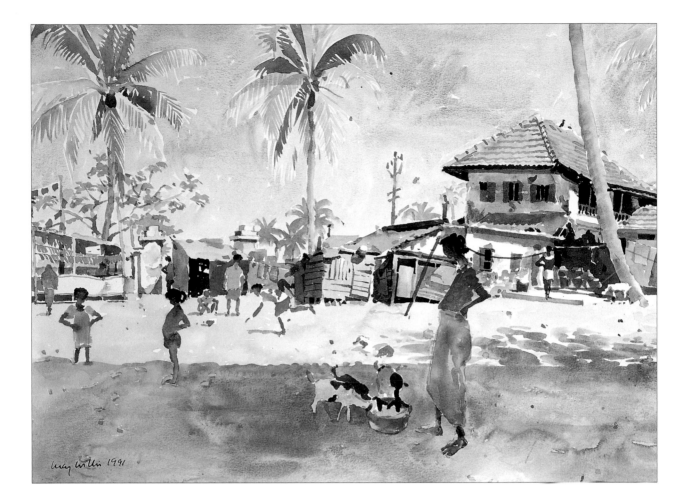

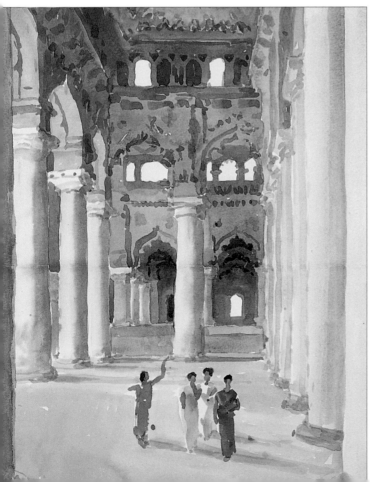

◀ *Palace, Madurai*
430 × 305 mm
(17 × 12 in)
The addition of the figures contributes a sense of grandeur to the scene; without them it would be difficult to imagine the scale of the pillars and architecture, or the depth of the space in the picture.

Yatama's Goats
430 × 635 mm
(17 × 25 in)
Having practised painting numerous figure studies in watercolour at home I was able to introduce this woman and her goats into the painting when they briefly appeared in my view. I used just a few shapes of limbs and clothing to suggest her stance. The children were tackled in a similar way but were painted even more quickly as they were constantly on the move.

121

Flesh tones

Skin can be just about any colour, depending on the light, as shown in the demonstration on page 124. My basic mixture for skin tones consists of Cadmium Red, Cadmium Yellow and Winsor Violet in different quantities, according to the subject – skin tones can vary widely from person to person. For dark-skinned people I add more Winsor Violet and Cobalt Blue to my basic mixture of Cadmium Red and Cadmium Yellow to achieve the deeper browns.

Remember that skin is translucent and sometimes has a reflective surface that is affected by the quality of the prevailing light and the colours in the immediate environment. It is a mistake to think that skin can be painted in straightforward pinks, 'flesh' colours or browns, with the addition of black for the shadow areas. Darken your flesh tones by adding more red, blue or violet and look for reflected colours on the surface of the skin – often you will see hints of green or blue, especially when painting figures outside, reflected from the surrounding foliage and sky. Develop the confidence to paint what you see, rather than what you think you know about your subject.

It also takes courage to paint skin colours as bright and warm as they really appear. Seen in isolation, the orangey-red of the skin of the nutmeg lady on page 117, might seem unrealistically bright, but in the context of her position in the sunlit doorway and counterbalanced by the cooler blues in the rest of the painting, this bold colour accurately describes her skin tone.

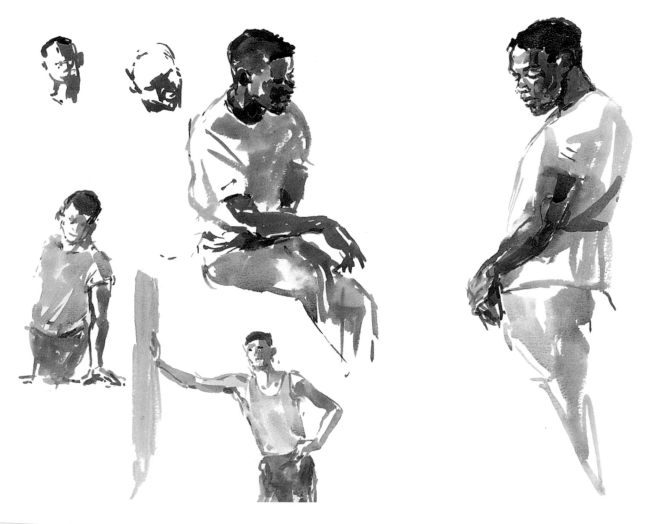

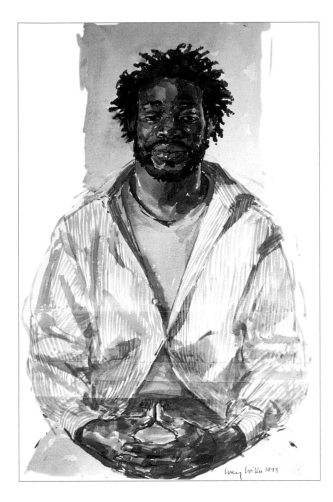

◀ *Figure Studies*
430 × 635 mm
(17 × 25 in)
The skin of the white man (on the left) has been left as bare white paper where the light struck his face. I used a mixture of Cadmium Red, Cadmium Yellow and a touch of Winsor Violet on the shadow side of his face; for the two black figures I added a lot more Winsor Violet and Cobalt Blue to this basic mixture to achieve the cooler brown tone of their skin. Notice how the light-struck sides of these black faces are a pale blue.

Portrait of Gavin (detail)
255 × 180 mm
(10 × 7 in)
This study was painted under overhead strip lighting with some daylight, too. There are one or two white highlights on the nose and lips, but generally the lightest parts of the face have a very pale blue tinge, and the rest of it is 'modelled' by the juxtaposition of the numerous facets of blues, greys, browns and touches of warm orange.

PAINTING A PORTRAIT

A watercolour portrait is possibly the most difficult thing to paint because your aim is to achieve a good likeness of the person as well as a good painting. To catch the likeness great care must be taken to position the features within the face correctly and to study the proportions closely. Whereas in oils you can more easily move an eye a little to the right or left, for example, in watercolour you must try to get these features in the right position straight away to ensure the freshness of your picture.

Striking portraits can result from placing your sitter in strong light which creates raking shadows, although this can also create difficulties. Diffuse light is much easier for painting a portrait because it gives subtle definition to the forms and a soft light on the face creates just enough descriptive highlights and shadows. So it can be a good idea to position your sitter in a well-lit situation where the light is fairly stable. You will also have plenty of time to complete your painting.

Start by carefully marking the essential proportions and then washing in some general areas, looking for the main angles, masses, shapes; noting each change in tone or colour. Notice the warm and cool colours in the shadow areas, and plot where the lightest areas are – how the light is reflected in the eyes and the way in which it creates highlights on the nose and lips. Look carefully at how the 'whites' of people's eyes usually have a subtle tone, except where they catch the light. Don't make the mistake of leaving them white, especially as they may often be partially or completely in shadow.

The light reflecting off the white of watercolour paper plays a crucial role in creating the impression of the skin's natural luminosity, so it is important to keep your colours clear and fresh.

DEMONSTRATION: TONY

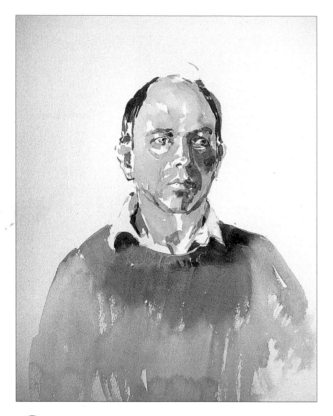

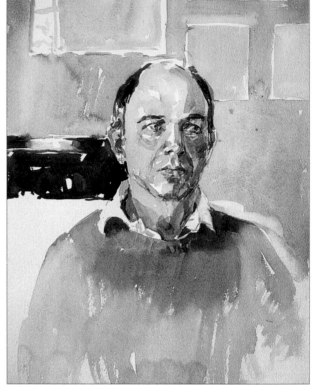

Capturing the likeness of someone is dependent on more than just describing the individual features correctly. Look instead at the general shapes, tones and colours and start with the basic framework, checking that the proportions of, and between, each feature are correct, before developing the details.

▲ STAGE ONE
Here, the face was divided down the middle into a light and dark side. After establishing the position of the features I put a shadow tone over most of the right-hand side. I mixed the colour from Cadmium Red, Yellow Ochre, Cerulean Blue and Winsor Violet and varied the quantities in the combination as I went down from the forehead to the chin. I blocked in the shape of the sweater, leaving the shirt collar white.

I toned down the light side of the face and neck with very light pink, leaving white paper showing for highlights on the forehead, nose and around the mouth. I then worked into the shadow side again with more greys and oranges.

▲ STAGE TWO
Next, I began to put in the background, bearing in mind that eventually the light side of the head would be against a darker tone and the dark side against a lighter one.

▶ STAGE THREE
Finished painting:
Tony
430 × 345 mm
(17 × 13½ in)
Concentrating now on the subtle tones of the face, I softened the inner corner of the left eyebrow and shadow beneath, which changed the expression slightly. Finally, I laid another darker wash over the left part of the wall in order to set the head forward in space a little more. I decided to leave the jumper as it was, showing the earlier, looser brushwork.

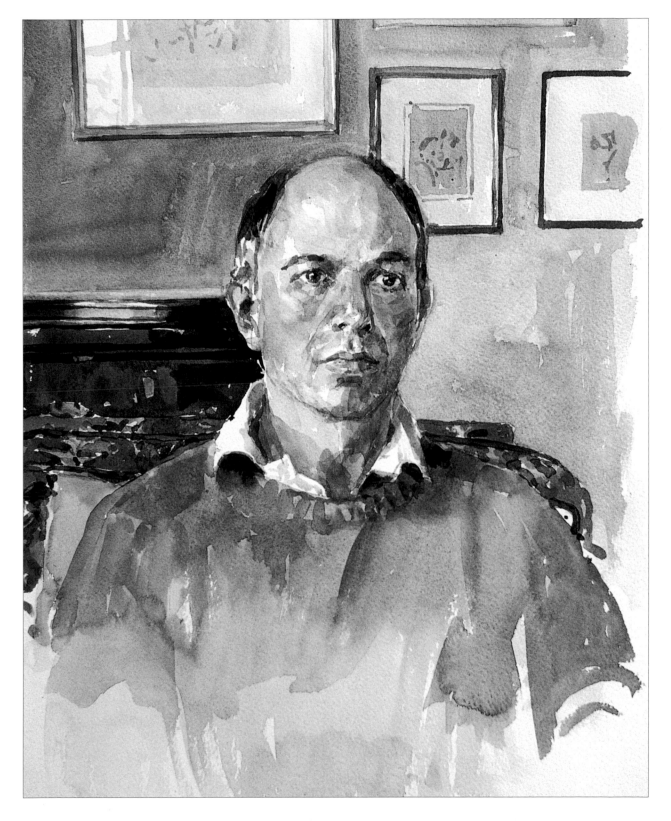

INDEX